A–Z

OF

BOLTON

PLACES - PEOPLE - HISTORY

Dave Burnham
with photographs by Brad B. Wood

AMBERLEY

For Arthur, Georgie, Theodore, Oscar, Liam and Brendan

First published 2022

Amberley Publishing
The Hill, Stroud, Gloucestershire, GL5 4EP
www.amberley-books.com

ISBN 978 1 3981 0235 4 (print)
ISBN 978 1 3981 0236 1 (ebook)

British Library Cataloguing in Publication Data. A catalogue record for this book is available from the British Library.

Typesetting by SJmagic DESIGN SERVICES, India. Printed in Great Britain.

Contents

Introduction

No brief volume can claim to be a comprehensive introduction to any town. Choices have to be made about what is included. While any 'A to Z of Bolton' must include Samuel Crompton, Fred Dibnah and the Man and Scythe, other entries here – the Cottontown Chorus, Paul Moulden and Booth's Music, for instance – may raise eyebrows. So, a word about the selection of entries is required.

Bolton is the biggest town in the UK and has an extraordinary industrial and cultural heritage. With cunning inventors, clever investment, courageous and sometimes ruthless entrepreneurs, Bolton was a driving force in Britain's Industrial Revolution. As Bolton spun the finest cotton yarn in the world, great wealth followed. This was accompanied by the constant clamour of forges, mill hooters and shunting yards, a soot-laden atmosphere that quickly turned the new Town Hall black as night, and 'fly' (floating cotton motes), which turned insides of mills white. The fly led to lung disease, the clattering machinery caused accidents and the work was hot and repetitive. But people did have work: pitmen, weavers, engineers, spinners. From little piecer to mill manager, their work defined them. It was possibly monotonous and soul crushing, but all knew their work was significant, keeping them and their families contributing to Britain's international standing and giving meaning and purpose to the place they lived. As a result, people's pride in Bolton was second to none. They may have known little about life outside the town, but their pride was real.

And Bolton folk had a lot of fun, eagerly celebrating annual rituals: the New Year Fair, walking days, wakes weeks and Christmas. Bands and sports teams abounded too, and there were three great theatres. Later, Bolton had more cinema seats than anywhere else, and who could carp at 300 pubs and nearly as many chip shops? Well, some did: the temperance lobby was heavily supported by Nonconformists whose places of worship outnumbered Anglican and Catholic combined. And church groups were also to the fore in the charitable efforts made to combat child poverty, TB and syphilis.

The town had a cast-iron purpose, but this has now gone. Bolton, like many other industrial towns, has lost that sense of itself. And while regeneration schemes are underway and employment and housing are good, reminders of what once was are everywhere. Walk into the surrounding hills and you see overgrown lodges, canalised waterways and abandoned workings – broken souvenirs of past times. Surviving mill buildings now house a range of activities, but they stand there, big beyond understanding, a rebuke to the modern world.

To some, such ruins are aching reminders. To younger people they are just history, vague and distant. Some only see shuttered shops and the shiny blocks of glass and

steel replacing them. So the town is in transition, looking half demolished or half completed. This messy state garners two responses. The first is dour pessimism: 'What's happened to our town? It's gone'. At the other extreme, there are regular attempts to big up Bolton, accompanied by the jollity of a marketing campaign that would have us all drink the Kool Aid.

Neither attitude is attractive, but we live in an age of simple bandwagons. It is tempting to jump on one and condemn anyone who disagrees. This little volume aims to weave a path between the two positions, spinning fine twist from three features of local life: continuities, connections and fun.

- Continuities between the past and the present – there are many that are unique to the town.
- Connections across town. Bolton is a compact community and there are odd links between people and places that might seem to have nothing in common.
- And fun. Well, that's just fun.

I hope you enjoy it.

To Eddie

Dave Burnham

Arkwright, Richard (BL1 4TG)

Let us begin at the beginning. Bolton was a village nestling on a promontory above a curve in the River Croal with a church perched right at the edge. A broad bowl of agricultural land surrounded it, rising to moorland on three sides. The landscape was ideal for rearing sheep and streams sweeping down the hillsides were perfect for powering mill wheels. Spinning, weaving and dying wool became a key feature of local life, with Bolton a market centre for the trade.

From the seventeenth century families were spinning fustian – mixtures of wool, flax, and then cotton as bales of that light, versatile, fashionable material became available from Anatolia. Traditionally, two women spinning (always women) could supply a weaver (mostly men) with enough yarn. Bury man John Kay's flying shuttle made weaving a quicker process in the 1740s and soon a weaver had to have half-a-dozen spinners to provide enough yarn.

Many attempts to speed up spinning followed. There was Oswaldtwistle weaver James Hargreaves' spinning jenny (1764), Preston-born, but Bolton resident, Richard Arkwright's water frame (1769), and Bolton inventor Samuel Crompton's spinning

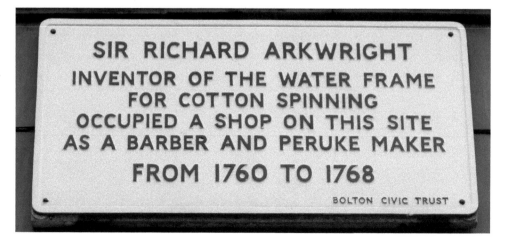

The Arkwright plaque in Churchgate.

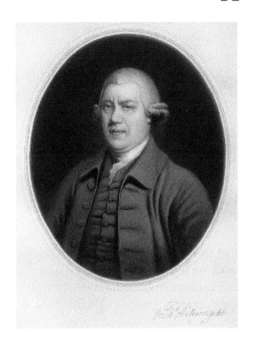

Richard Arkwright. (© Bolton Council.
From the Collection of Bolton Library and
Museum Services)

mule (1779). Hargreaves and Crompton were imaginative craftsmen, but Arkwright was something else. He lived in Bolton's Churchgate from 1752, working as a barber but also selling wigs. On his travels, collecting hair for wigs, his attention was grabbed by the race to automate spinning. Seeing an opportunity, Arkwright employed John Kay, Warrington clockmaker, and Leigh carpenter Peter Artherton to complete their work on an efficient spinning device. He patented what was produced and put the machinery to work immediately. Arkwright's water frame was so bulky it had to be powered by mill races.

Although synonymous with his name, Arkwright's real claim to fame is not the water frame, but what he did with it. First in Cromford, then elsewhere, Arkwright chose sites near powerful watercourses and gathered together his machines and scores of women and children to operate them: the first industrial mills. Along with Boulton and Watt in their Soho ironworks in Birmingham, Arkwright shares responsibility for creating the uniquely efficient, fabulously successful and much hated factory system.

Ashworth, Henry (BL1 8RY)

Boulton and Watt's steam engines soon replaced water to power mills, and huge slab-sided buildings came to dominate the Lancashire landscape. Dark and Satanic indeed – no misnomer to those whose lives were dominated by them. By the 1820s these efficient behemoths had priced homeworkers out of the trade. Many responded with demonstrations, then machine breaking, but this barely slowed industrialisation. Once in a mill, the operatives spent twelve-hour days working to the other man's clock,

the other man's rules, and were even sometimes only paid in vouchers redeemable in the other man's shop. Some of these other men were already affluent, but many were weavers themselves who took their courage in their hands, clubbed together and borrowed money to build one of the stone leviathans. In popular culture, including books by Bolton saga writer Ruth Hamilton, mill owners are often portrayed as hard hearted, grasping and lecherous. Some were like that, but others remembered the privations of manual work and eased the burden of their workers with gardens, libraries and sports facilities. Bolton developed a reputation for model workers' villages built by mill owners: the Dean Mill complex at Barrow Bridge, Ainsworth's St Peter's Place in Halliwell, Greg's village at Eagley Mills and Henry Ashworth's Bank Top village above New Eagley Mill.

Henry's father, John, was a cotton agent buying yarn and cloth from local weavers to sell in Manchester. In 1793 he built a spinning mill by Eagley Brook. A Quaker, he sent young Henry to the Society of Friends school at Ackworth before the lad joined the mill. Henry and his brother Edmund expanded the site, employing 260 operatives by 1831. A successful industrialist, young Henry also gave something back. He built generous-sized cottages for his workers, which were regularly painted and repaired. His mills had washrooms for workers and the site boasted a reading room, cricket pitch and bandstand. But expectations of the workforce were severe. Anyone caught

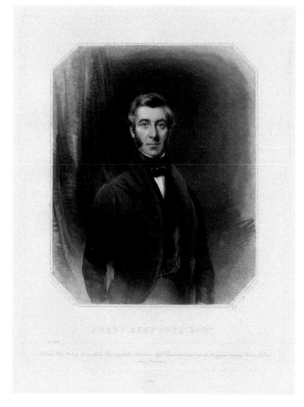

Henry Ashworth. (Courtesy of the National Portrait Gallery)

in drink was sacked and rule breakers were ruthlessly disciplined. Trade unions were opposed, but Henry and his brother Edmund were insistent that operatives' children should all have access to education. His reputation for severe discipline as well as philanthropy was based on his belief in freedom of conscience. He provided the wherewithal for self-improvement and people could make of that what they would, as long as they obeyed the rule of the mill.

Ashworth was also active in local politics and was the first Quaker to be made a magistrate. His ambition did not stop there. In the 1830s he became the touring partner of the Anti-Corn Law League, which agitated against the law introduced in 1815 to keep the price of grain artificially high. High prices benefitted the landowning cabal that dominated Parliament but led to bread priced beyond working people's means. Want and starvation followed. Henry Ashworth became the A of the ABC of the campaign: Ashworth, Rochdale's John Bright, and Manchester-based Cobden, all of whom were involved in the cotton trade. They triumphed eventually when yet another cotton man, Prime Minister Robert Peel, steered the repeal through Parliament in 1846.

Like so much of Bolton's industrial heritage, nothing is left of Ashworth's mill, save the core of a chimney stack by Eagley Brook.

Site of New Eagley Mills.

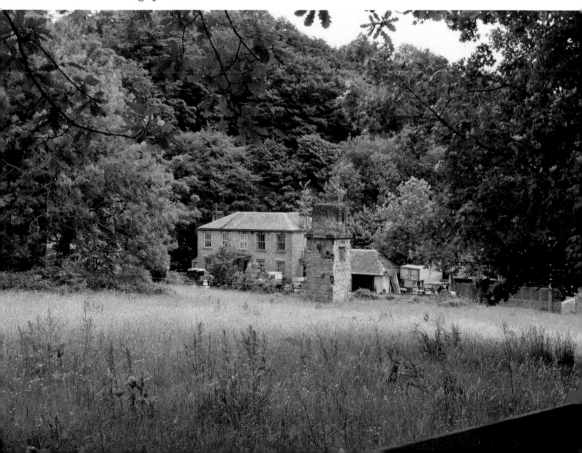

Barlow Institute (BL7 0AP)

Son of a handloom weaver, James Barlow's first forays into business in the 1840s failed. Finally, with Mr Jones, he prospered. By the 1880s Barlow and Jones ran four Bolton mills (Albert, Egyptian, Prospect and Cobden), had warehouses in Manchester and representatives in London, Paris and New York. They sold 'Osman' quilts, bedding and towels – a worldwide brand.

As well as ambition and energy, many of the successful spinners in nineteenth-century Bolton shared three other characteristics with James Barlow: Nonconformity, philanthropy and temperance. James Barlow himself became Mayor of Bolton, built a grand house, Greenthorne, on the edge of the moors at Edgworth and gave generously

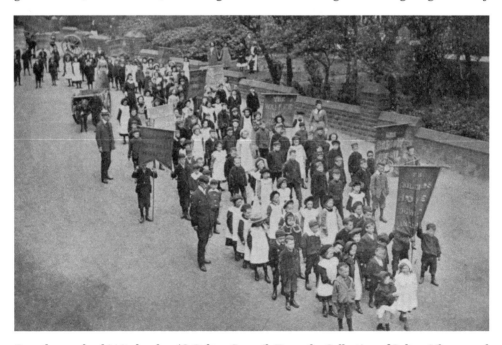

Crowthorn school in its heyday. (© Bolton Council. From the Collection of Bolton Library and Museum Services)

Barlow Institute.

to local charities. One significant piece of generosity was the land he gave to fellow Methodist Thomas Stevenson, who built a huge campus for orphaned children, Crowthorn.

Barlow's children and grandchildren were similarly able and had the benefit of an education and money behind them. James's son, Thomas, left Bolton for a prestigious medical career in London, ministering to Queen Victoria on her deathbed, discovering the genesis of childhood scurvy and serving as president of the Royal College of Physicians.

Thomas's son, Sir Alan, became Parliamentary Private Secretary to Ramsey McDonald when prime minister, and gathered an unrivalled collection of Islamic art, which he donated to the Ashmolean Museum. His sister Alice pioneered the boarding out of children 'under control' of the Poor Law with ordinary families rather than keeping them in the workhouse. Another sister, Annie, collected ancient Egyptian artefacts, creating much of the extraordinary collection now in Bolton Museum. Ruth Padel the poet, Oliver Padel the historian and Phyllida Barlow the sculptor are also from that same family line.

The physical legacy of all this family achieved is the Barlow Institute. This handsome building, for use by Edgworth villagers, was funded entirely by Sir Thomas Barlow in memory of his parents, James and Alice. Opened in October 1909, this Arts and Crafts creation sits amid the Recreation Ground, an earlier bequest by the Barlows. Now run independently by local people 'the Barlow' holds meetings, fairs and other entertainments – the key venue for anything happening in Edgworth.

Barrow Bridge (BL1 7NH)

In 1840 a young novelist visited Bazley and Gardner's new model village at Dean Mills. He came to see the neat terraces of workers' cottages, the row of managers' houses behind a bubbling stream, the institute and the schoolroom. In the resulting novel, *Coningsby*, the village appears as Millbank. One of the protagonists in the book, Oswald Millbank, may be based on Henry Ashworth, local mill owner and Anti-Corn Law League activist. Disraeli, the author of *Coningsby* and future prime minister, coined the phrase 'Two Nations' to describe the vast and widening gap in industrial Britain between owners and operatives – epitomised by the gulf between the vast wealth of Bazley and Gardner and their workers.

The cottages *Coningsby* describes are still there, although the works have gone save for a single commanding chimney. Once the bustle of cotton production waned, tranquil Barrow Bridge became the destination for thousands of summer weekenders who wandered along with an ice cream or made use of the crowded boating lake. That lake is also no more.

Barrowbridge managers' houses.

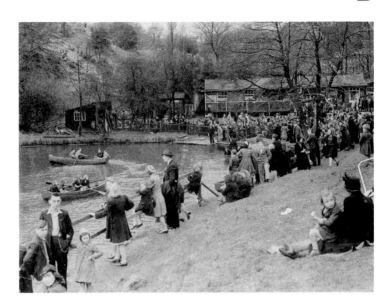

Barrowbridge,
summer 1950.
(Courtesy of *Bolton
News*)

Today you can still walk up the sixty-three steps leading to the heights of Winter Hill. These steps, like much across Bolton, were not built with a Sunday stroll in mind, but for the practical purpose of enabling colliers to reach the pits up the hill at Burnt Edge.

Bolton Little Theatre (BL1 4TG)

'The Beating Heart of Theatre' in Bolton has been beating since 1931. There were three fine theatres in town, but the Hippodrome and Theatre Royal were being used as cinemas and the Grand offered variety shows. A few members of the long-standing Bolton Dramatic Society (BDS), frustrated by lack of rehearsal space for their own productions, saw an opportunity to establish a permanent home for amateur theatre. The proponents of this radical plan – Tom and Jean Sefton, Elizabeth Lee and John Wardle – were expelled from the BDS. The breakaway group formed a new entity, which in 1934 took possession of the building still occupied today – Bolton Little Theatre (BLT). This building had started life as the Coronation Forge and was later a Poor Law night shelter, then a boxing stadium and during the Second World War it was requisitioned as a sugar store. Early benefactors Bill Hanscomb and James Wigglesworth set the theatre on its feet, but the place thrives through the unceasing efforts and steady passion of scores of volunteers. Comedy actor Brian Pringle, Malcolm Tierney and Sir Ian McKellen all started their careers in this backstreet building.

Currently the main auditorium seats 163 and the Forge, a studio space, sixty-one. In 2019 there were sixty-two performances of eight separate plays, as well as many events arranged by groups hiring the theatre.

Bolton Little Theatre.

All this has been achieved by voluntary effort. There are over 200 members and forty or so regular volunteers. This band of sisters and brothers takes on a vast range of tasks from front of house to lighting and painting walls. There are also sound technicians, carpenters, bar personnel, actors and stage managers doing one thing one day and perhaps something different the next. And the pressures are constant: the wrangling about what plays to offer, changes to fire safety legislation, maintenance of a 200-year-old building, rumour upon rumour about development plans for the land around about and rising expectations of audiences. All this has to be managed and paid for, making fundraising a relentless consideration. But the constancy of volunteers has helped BLT thrive over the years. Some offer decades of continuous service, others get involved as young people and return once they have retired.

Bolton has the largest amateur theatre network in the UK, BLT being just one of many local theatre groups – Farnworth Little Theatre, Horwich Amateur Theatre Society, St Joseph's Players Leigh and the Bethel Crowd Drama Group Westhoughton are just a few.

Bolton School (BL1 4PA)

Long before Bolton was a cotton town it was a market town. After the turbulence of the Wars of the Roses, from 1485 peace in England led to a stronger trading economy, which needed literate young men. Around then a score or so of grammar schools were founded in the north-west of England, Bolton School being established sometime before 1514. The destruction of the monasteries during the Reformation a few years later obliterated the role of the Church in education and the availability of printed

Bolton School.

texts increased the need for literacy, embedding the role of grammar schools across society. Bolton School sat hard by the parish church, teaching the sons of clerks, solicitors and traders for over 300 years. In 1899 the school moved to Chorley New Road and in 1913, at the behest of William Lever, the boys' school and the high school for girls merged. Lever re-endowed the whole enterprise generously, funding the grand frontage and impressive interior, which was completed in 1924.

Now one of the most prestigious schools in the North West, former pupils not only make up a considerable number of the great and good of the town but include film encyclopaedist Leslie Halliwell, Egyptologist Joyce Tyldesley, writer Monica Ali, Nobel prize-winner Sir Harry Kroto and actor Sir Ian McKellen.

Booths Music (BL1 1HU)

In 1832 the Reform Act extended the vote to include men who owned £10 of property, the affluent middle class. Bolton at the time had no MP and was run by a board of trustees: magistrates and landowners, the Bradfords, the Stanleys, the Hultons. But local entrepreneurs were setting up steam-driven cotton mills and engineering works. These were the days when mills and churches started supporting brass bands, when the first music hall appeared in Bolton and when working people took to learning proper musical instruments rather than playing in drum and fife bands. The Booth brothers took the opportunity to establish a small emporium selling musical instruments. They and their descendants stuck at it.

 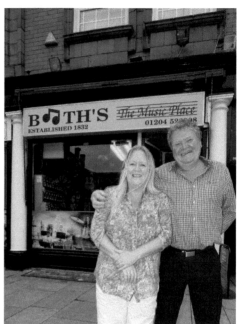

Above left: Booths, 1880. (Courtesy of Tony Booth)

Above right: Tony, Jean and Booths today.

Booths has moved around since, but has been established in Churchgate for around 150 years. Currently Tony and Jean are in charge, Tony being the great-, great-, great-, great-grandson of one of the founder brothers.

Booths does not just sell instruments, but offers advice, good craic, repairs and ten teaching rooms. Over the years, thousands have scraped and plonked, blown and banged their way to musical excellence – or something like it. Booths is a fixture, an institution, arguably Bolton's musical centre and the oldest independent music retailer in the UK.

C

Churchgate (BL1 1HJ)

Churchgate, the site of the parish church and the Man and Scythe, is where Bolton began.

Until the nineteenth century the wide street was packed with stalls on market days, the commercial hub of the town. When the market and market cross were moved to what is now Victoria Square, Churchgate turned to fun. It already boasted a cockfighting pit and the junction with Bradshawgate was where traditional holiday street football games kicked off. The mid-nineteenth century saw modern entertainment arrive. At one end of Churchgate in the parish church, Canon James Slade, the vicar of Bolton, laboured to improve the lives of workers by starting a medical dispensary

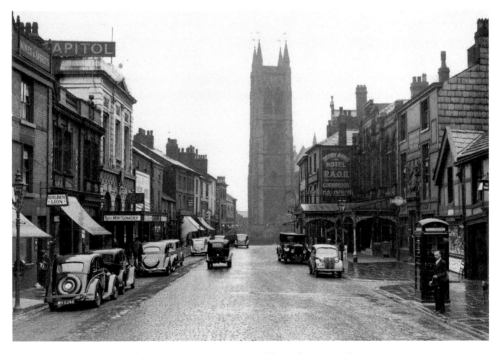

Churchgate in 1940. (Unknown provenance, possibly *Bolton News*)

and savings bank, but 100 yards away workers chose to escape their miseries in the vast amusement complex of the Star Music Hall, which opened in 1840. One of the first of its type, the building contained a concert hall for 1,500 people, a menagerie and waxworks, all fronted by a pub. Plays, music, tableaux vivants, 'hydrogen gas phantasmagoria', 'Ethiopian Entertainments' and acts such as 'Booth, the one-legged jumper' graced the programme. The Star was fabulously successful, earning the opposition of other pub owners and supporters of 'Rational Entertainments'. Sadly, though, the Star burned down in July 1852.

By 1900 the street, only 150 yards long, boasted a billiard hall, two great theatres (the Grand and the Theatre Royal), Smokey Joe's temperance bar, theatrical lodgings and seven pubs – the Golden Lion, Legs of Man, Concert Tavern, Derby Arms, Man and Scythe, Boar's Head and the Swan. At that time the landlord of the Derby Arms was James Billington, who had started working in a mill, graduated to hairdressing, then crowned his career as Britain's chief hangman. He hanged 144 murderers and introduced three of his sons, John, Thomas and William, to the trade, becoming head of Britain's most extensive dynasty of hangmen. But the family's fall followed swiftly on James' final hanging on 3 December 1901, when he dispatched murderer Paddy Mckenna, a local man he probably knew. James himself died of pneumonia ten days later, followed swiftly by the untimely deaths of his second wife Alice (possibly from drink) and sons John and Thomas (both from respiratory ills). Young William seems to have taken to drink too, as many hangmen did, abandoned his wife to the mercies of the Poor Law, was jailed for it, then disappeared.

From 1928 the plush Capitol Cinema and Valentino Sabini's ice-cream parlour strengthened Churchgate's popularity, with singers, peanut sellers, preachers and gaudily epauletted commissionaire Mad Jack Clemson enlivening cinema and theatre queues. But times change. Both theatres were pulled down in the early 1960s, replaced by dull office blocks. But the tradition survives in the four pubs that remain: the 180-year-old Booths Music, 130-year-old Pastie Shoppe and nearly 800-year-old Man and Scythe.

Cotton Mills (BL1 2JS, BL3 3AG, BL1 7LS)

In 1900 around 50,000 people, nearly a third of Bolton's population, worked in textiles – spinning, weaving, dyeing and bleaching. Thousands more worked in support industries – leather belting, mining, transport, engineering and pattern design.

British nineteenth-century wealth was generally based on local resources: wool, fish, coal and iron ore. Cotton does not grow anywhere near Britain, let alone Bolton, so why was this startlingly successful industry here? In truth, Lancashire's cotton industry was an aberration – one that lasted 200 years, but an anomaly nevertheless. In 1760

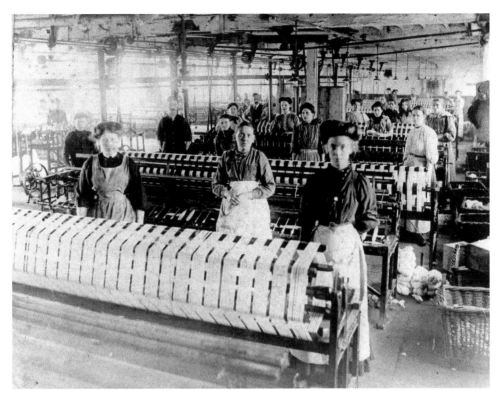

Rumworth reeling works. (© Bolton Council. From the Collection of Bolton Library and Museum Services)

nearly all the cotton clothing worn in Britain was imported from Bengal. A hundred years later nearly all the cotton clothing worn in Bengal was made in Lancashire. Now, as I write, I am wearing a cotton/linen mix shirt ... made in Bangladesh. Clever inventions followed by breakneck industrialisation in Lancashire enabled by a sophisticated banking system, easy credit and government manipulation of tariffs, supported the establishment of a British cotton industry. This was aided in the late 1700s by British command of the seas, rapid fire muskets and the collapse of the Mughal Empire. The British then suppressed the extensive Bengali cotton industry. Industrial dominance was sustained by an unending supply of raw cotton from the USA, grown by enslaved people on stolen land. But a century later, exported machinery (made in Bolton) and cheap labour helped Japan, India, Bangladesh and China price Lancashire yarn and cloth out of the market. During the 1980s there was something of a revival of production of specialist synthetics in Britain, using state of the art spinning systems, but then many British firms entered joint ventures with China, moving production there. But even today Pincroft in Adlington is a leading producer of workwear, and Lantor, on Deane Road, produces industrial non-woven textiles.

Bolton still boasts a number of mill buildings, including its oldest, the biggest and the newest. Although the current St Helena mill was built in 1820, a previous building

Above left: St Helena Mill – the earliest.

Above right: Swan Lane Mill – the biggest.

Left: Holden Mill – the last.

there was spinning yarn in the 1770s, yards from the King Street site where Crompton himself later laboured. Yarn was spun in St Helena for nearly 200 years, though now it houses the local Probation Service. Up towards Daubhill is Swan Lane mill, uniquely attractive with Italianate touches and terracotta embellishments. Although now housing a range of businesses, when built in 1906 Swan Lane was the biggest mill complex in the world. At the other end of town Holden's Mill in Sharples, completed in 1927, was the first built to be run on electricity, the last built in Bolton and arguably the last built in Britain. An imposing building it now contains spacious apartments.

Cottontown Chorus (BL7 9LT)

Bolton's musical tradition can be traced back to the founding of the Choral Society in 1819, the Philharmonic Society in 1836, the Harmonic Society and the People's Concert Society, both in 1853. Brass bands were established through the nineteenth-century mills and churches, the most famous being Wingates. Jack Hylton (Britain's King of Jazz), band leader Alyn Ainsworth, McFly, Spyrogyra, Annie Haslam, the Buzzcocks and jazz musician Arun Ghosh all came from Bolton. Today The Managers swing band, quirky ukulele outfit the Nanukes of the North, Nat Clare and the Cider

Cottontown Chorus. (Courtesy of George Denton)

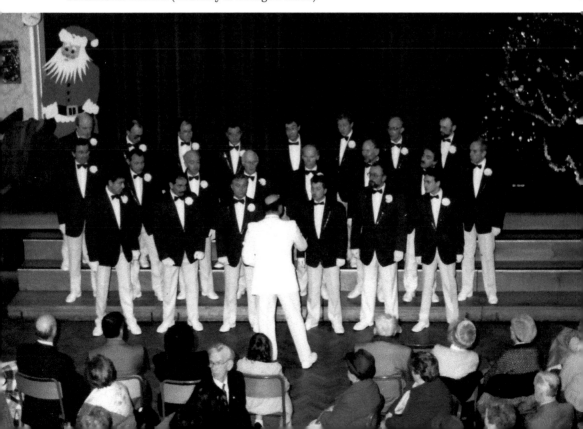

'Ouse Entourage provide local melody for local ears. However, the most unexpected and possibly most successful musical ensemble in town is a barbershop choir. Barbershop? That's American isn't it? Well, tell that to Bolton's own sixty-strong Cottontown Chorus, who rehearse every Tuesday at Turton School and perform all over the country. Their music can be haunting or raunchy, intimate, intricate or sad, but all their pieces are melodious and powerful. Regular winners of the National Barbershop Championship and frequent contestants in the world championships, there can be no doubt about it that Bolton's Cottontown Chorus are leaders of the British barbershop scene.

Crompton, Samuel (BL2 3AG)

Firwood Fold, a tiny, cobbled enclave consisting of two rows of quaint cottages, comes as a delicious surprise whether you approach up from the industrial estate or down from Crompton Way – worth a visit even if Samuel Crompton had not been born here. Crompton, inventor of the spinning mule, lived here until he was six, his parents getting by through agricultural work, hand spinning and weaving. His dad died, though, and young Sam had to step in to make ends meet. The family eventually settled 700 yards away at Hall I'th Wood, a listed building now, gaily Tudor beamed and a jewel of a museum. In Crompton's day it was a tenement. The young man had a struggle producing decent yarn on Hargreaves' spinning jenny and, being inventive, designed an alternative. By 1779 Sam had built what he called the Hall-ith-wood-

Firwood Fold.

wheel, later known as Crompton's mule. For Lancashire's cotton industry the mule was a game changer. The original was light, easy to use, fast and capable of producing finer yarn than any other spinning machine. And the quality was uniform – every hank perfect. The superiority of Crompton's yarn was soon noticed in the market, and he saw people peering in his window to see how he conjured it up. Perhaps even Arkwright made a surreptitious visit to cadge the secret. Crompton's clandestine machine could not be hidden and, untutored and poor, applying for a patent was beyond him. He also spurned the offer of a partnership with Robert Peel, suspicious of the successful Bury spinner's motives. Local mill owners promised payment for using his idea and Sam revealed the mule to all. Little money came to him as a result. Subsequently he set up a small factory in King Street with six employees and invested in a dye works in Darwen. But he was no businessman and neither prospered.

At the end of his life he lived off a small pension, meagre profits from spinning and tinkered with a mechanical device he had made for washing clothes. Regarded as a melancholy soul and burdened with adult children who expected more benefit from their father's fame than he could provide, Sam nevertheless gained solace from his music, playing the organ at the Swedenborgian church in Bury Street. Only after his death was his contribution to the world fully recognised.

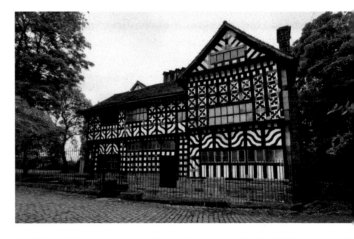

Hall I'th Wood.

Crompton's King Street workshop as it was demolished. (Courtesy of Halliwell History Society)

Derby, Earls of (BL1 1HJ)

The Stanley family have been prominent throughout the North West from 1485 when Thomas Stanley changed sides during the Battle of Bosworth Field, betraying Richard III and backing Henry Tudor. For his pains Stanley was made Earl of Derby. Since then, the Stanleys have successfully navigated many other religious and political upheavals. Today the 19th Earl resides in Knowsley Hall. Between these two the 2nd Earl took a band of Bolton lads to Flodden in 1513 to hurl back invading Scots; the 12th had the Epsom Derby named after him; the 13th helped Sam Crompton secure a small government pension; the 16th had Canada's Ice Hockey trophy, the Stanley Cup, named in his honour; and the 17th recruited Pals battalions in 1914. The names still feature in Bolton's landscape – Derby Street, Derby Arms, Derby Hall, Stanley Road, and so on – but few in Bolton revere the name. In fact, two of the earls in particular have wretched local reputations.

In 1554 Edward, 3rd Earl of Derby, had Protestant martyr George Marsh arrested, interrogated, tried and burned.

In 1651 James, 7th Earl of Derby, took the blame for the 1644 massacre of Bolton townsfolk during the English Civil War, though the army was led by Prince Rupert. Such massacres were commonplace in Europe's Thirty Years' War and occurred at Drogheda and Wexford in Ireland, but nothing like the Bolton massacre happened elsewhere in England. So why did it happen here? Prince Rupert, irritated by an earlier failed assault on Bolton in which he suffered many casualties, forbade 'quarter to any person then in arms, because they had so inhumanly murdered his men in cold blood'. And Derby's actions may have been 'animated by a just concern for the sufferings of his lady', in that Parliamentarians had laid siege to Lathom House, defended by his wife. The massacre's death toll was disputed, but a near contemporary figure suggests 1,200 dead with four clergymen killed and people in farms and hamlets all around slain, whether 'in arms' or not.

Derby, once captured, was tried in Chester, then, in a gruesome piece of judicial theatre, was brought to Bolton to be executed. Arriving at midday on 15 October 1651 Derby was said to have sat in the Man and Scythe and was beheaded at three o'clock near the market cross outside. Only around a hundred people gathered to watch and remained more or less silent as it was done.

Above: Man and Scythe inside.

Right: Bolton's market cross.

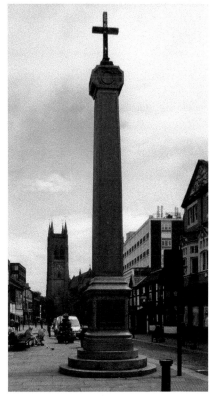

One mystery remains. The man who beheaded Derby, Whowell, was a Turton farmer whose family had been among the massacre victims. The supposed skull of this man resides at the Pack Horse pub in Affetside. The axe he used passed this way and that over the years and was owned by a James Pitney Weston in 1880 ... but where is it now?

Dibnah, Fred (BL2 1NU, BL1 1RD)

'I'm a Victorian. I don't do things like going shopping.' Victorian values possibly, though Fred was born in 1938. Steeplejack and steam engine enthusiast, Fred's fame came about as a result of a TV appearance working on the Town Hall tower. Further TV exposure followed, spiced with bluff comments, schoolboy enthusiasm and his bonfire-in-the-hole method of bringing down chimney stacks. Ironic that in spite of his northern industrial roots, it was the demise of the local cotton industry that kept him in work through the 1970s and 1980s.

Fred's other obsession was steam. The backyard of his house was an engineering cornucopia, where he spent twenty-five years rebuilding a 1912 Aveling and Porter steam traction engine. Honoured by the queen in 2004, Fred took it to London for his investiture but was refused entry to the palace grounds as the authorities feared the weight of the engine would ruin the Mall.

Fred Dibnah's house.

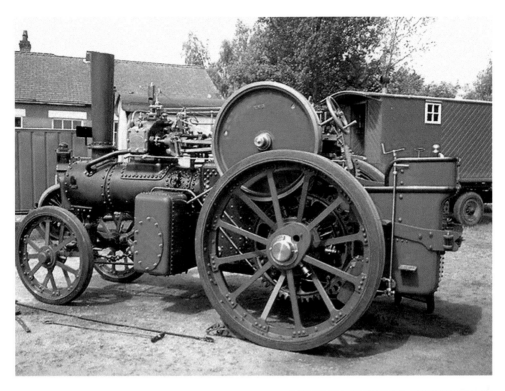

Above: Fred's refurbished Aveling steam tractor. (Courtesy of Brian Elsey)

Right: Fred's statue.

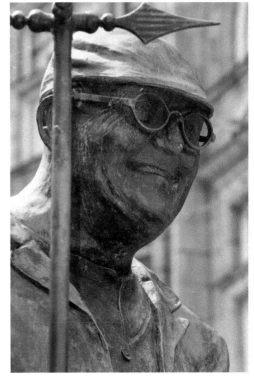

Fred, with his flat cap, boiler suit and cheeky-chappy grin, almost single-handedly created a wave of steam age nostalgia. Much-married Fred was a complicated character, but remained true to what he had grown up with. To the last his battered Land Rover was a frequent sight around town, as occasionally was his clanking, wheezing steam juggernaut.

His statue, unveiled in 2008, four years after his death, like the effigies of Victoria Wood in Bury and Mrs Pankhurst in Manchester, looks nothing like him. Stooped and gormless, the figure is the antithesis of Fred in life.

Dobbies (BL2 6RL)

Towards Bury on Bradley Fold Road stands a sports club. It has a bowling green, changing rooms, auditorium – the usual. It is called Dobbies, but why such a strange name? There are two clues locally, one is the large trading estate over the road from Dobbies. The other is the statue of Benjamin Alfred Dobson in Victoria Square. This pensive-looking, monocled figure, dressed in his mayoral robes, ran the engineering firm Dobson and Barlow between 1871 and 1898. Taking it over from his uncle, he expanded Dobbies – everyone called it Dobbies – and manufactured every conceivable type of

Dobbies sports club.

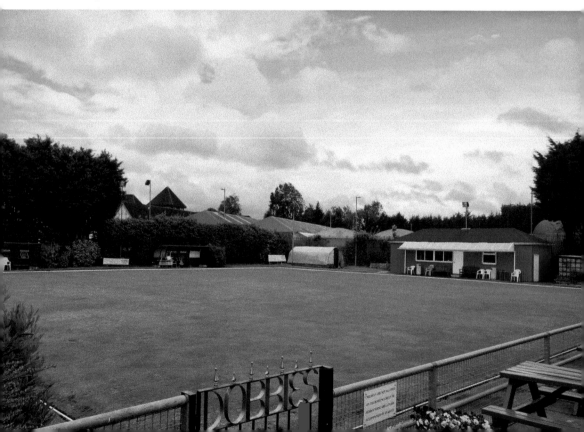

cotton production machinery. Benjamin sold machinery to Turkey, Egypt, India and Japan and travelled himself to oversee its proper installation. A determined champion of his business, he supported the establishment of the technical school (providing all the machinery) and broke the 1887 engineering strike by bringing in non-union labour – men in those days called 'knobsticks'. By the time Dobson died in 1898 Dobbies employed 5,000 people. All this came from the tiny enterprise formed by Isaac Dobson in 1790, one of the earliest engineering companies in the world. Much of its production moved from Kay Street to the vast site at Bradley Fold in 1906, where the sports club still stands.

The First World War saw Dobbies' production switch to hand grenades, mines and shells, and from 1939 aeroplane wings. Amalgamated with other textile engineering firms in the bad times of the 1930s, after the Second World War production at Bradley Fold continued as a subsidiary of Stone-Platt and thereafter slowly declined. The site closed in the 1980s.

The sports club is all that now remains of Dobson and Barlow, whose chimney was once claimed as the tallest in the world and whose reputation was one of the grandest.

Inside Bradley Fold around 1930. (© Bolton Council. From the Collection of Bolton Library and Museum Services)

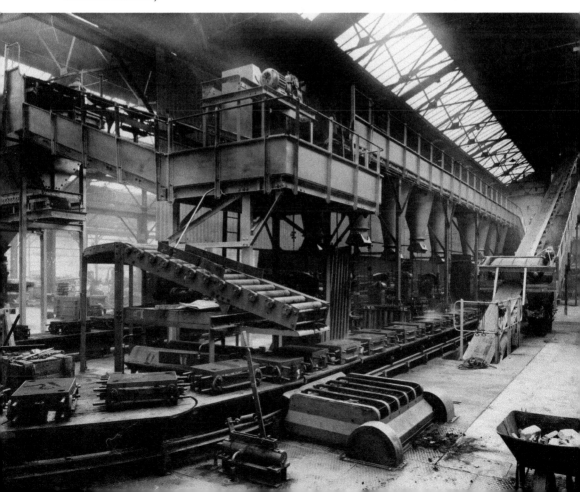

E

Egyptians (BL1 1SE)

Go to Bolton Museum and you can walk through an ancient Egyptian sepulchre. The tomb of Thutmose III is recreated there, dark as night, eerie as Halloween. But this is no fairground mock-up. The exhibits are authentic, among the 12,000 Egyptian artefacts held in Bolton Museum, one of the finest collections in Britain. But why Bolton?

Like much else in the town, cotton is the reason. Anxious to secure long staple cotton to make the finest of yarns, Bolton spinners such as Chadwicks of Eagley Mills started investing in Egyptian cotton production in the mid-nineteenth century.

Thutmose III, Bolton Museum. (© Bolton Council. From the Collection of Bolton Library and Museum Services)

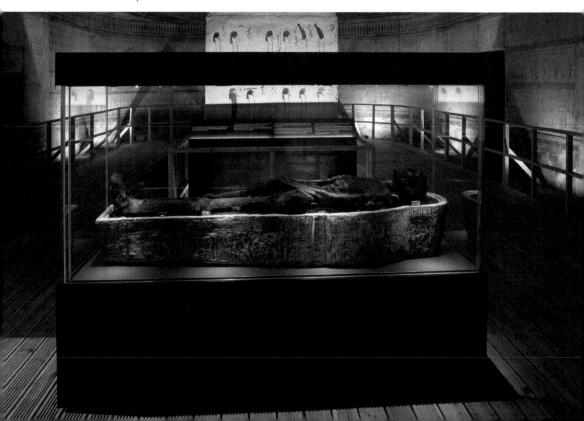

Professor Joyce Tyldesley. (Courtesy of Joyce Tyldesley)

This coincided with the emergence of archaeology as a science and Egyptology as both an academic subject and a source of popular fascination.

One of the companies involved was Barlow and Jones, and one of the key figures was Alan Barlow, who visited Egypt and collected Islamic art. His stunning collection is now in the Ashmolean Museum in Oxford. His sister, Annie, was fascinated by Egyptian artefacts and supported the Egyptian Exploration Society (EES) financially. As a local representative of the EES Annie visited Egypt herself in 1888 – some excursion for a single woman then. Her role with the EES enabled her to direct many finds to North West collections and Bolton Museum in particular.

Another legacy is a thriving local Egyptology and Archaeology Society whose president is one of the most highly regarded contemporary British Egyptologists. Joyce Tyldesley was brought up locally and has considerable field archaeology experience. She is Professor in Archaeology at the University of Manchester. She writes academic and also delightfully accessible books, concentrating on the lives of women in ancient Egypt.

Elephants (BL1 1TJ)

Elephants feature on Bolton Council's emblem, the university's shield, in Bolton Market on Ashburner Street and all sorts of other places around town. Every Boltonian

can explain the elephant, although everyone seems to have a different explanation. The most solid sounding is religious. Hundreds of years ago when northern England was big and empty Bolton fell under the diocese of Coventry, whose emblem was an elephant. But if that is the case why was the elephant first mentioned in Bolton only in 1799? This was by the clerk to the board of trustees (the town managers before Bolton had its own council). Bolton's first gas company took up the idea in 1818 and the image of the elephant with a castle on its back was formally claimed by the newly incorporated town in 1838. It seems likely that, like so much else in town, it is to do with cotton and particularly Bengal where there are real elephants.

Bolton's trade with Bengal took off before 1800 and expanded beyond yarn and cloth. The first ever steam engine used in India, at the Serampore Baptist Mission paper works in Bengal, powered a treadmill. It was made by Bolton's Thwaite, Hick and Company in 1821. But cotton was the primary export to Bengal. A significant feature of mule-spun yarn was its strength. Stamps on bolts of cloth indicating the manufacturer and type of cloth featured elephants from that date, signifying both strength and the reach of the town's trade. In Bolton it always comes back to cotton.

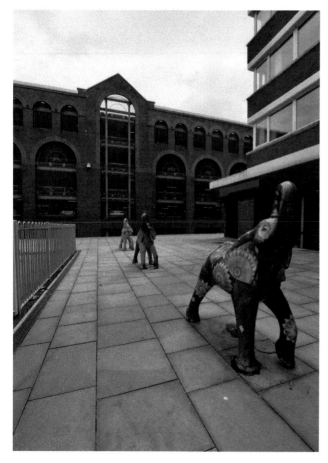

Bolton elephants.

Foxy (foxysclogs.co.uk)

Legend has it that in 1337 Flemish weavers arrived in Tonge Fold, invited over by Philippa of Hainault, Edward III's queen. This was supposedly the route by which clogs arrived in the country. But British clogs, with wooden soles and leather uppers are different from European, all wood sabots. The former became the ubiquitous footwear for working people across industrial Britain into the twentieth century. Long lasting, warm and dry, clogs were, most of all, cheap.

A century ago Bolton boasted seventy clogging shops. Although hard-wearing, the wooden soles needed protecting from setts (cobble stones), and clog irons, like

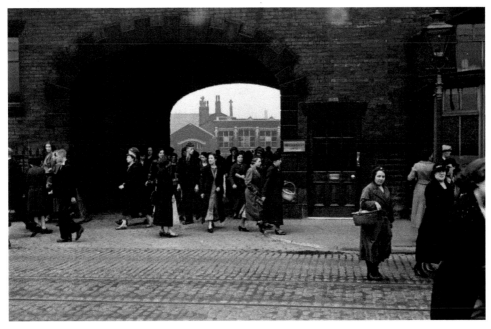

Women wearing leather shoes leaving Flash Street Mills. (© Bolton Council. From the Collection of Bolton Library and Museum Services)

horseshoes, had to be replaced every six weeks. This job took a couple of minutes, cost a penny, and the bright new irons gave children a chance to make sparks along the pavement as they skipped home.

The vast changes in what women wore brought about by the First World War sounded the death knell for clogs. Women in manufacturing needed less-restrictive clothing than was fashionable in 1914, so corsets, ankle-length skirts and long hair (dangerous around machinery) were replaced by freer skirts and blouses. Then the dance craze demanded lighter, leather shoes, which young women took to, so by the 1920s clogs and shawls were seen as old fashioned. In early documentary films from around 1900 all the women emerging from factory gates were wearing clogs. But their daughters and granddaughters captured by photographer Humphrey Spender in 1937, wore only leather.

Bolton's John Fox, 'Foxy', still makes clogs from scratch for morris teams and occasionally step dancers. He uses beech and shapes each pair after painstaking measurements, attaches the leather upper and does his own scroll work if the customer requires it. But there is a problem with the supply of metal rods, which are used for making clog irons. He can find no replacement source. Although there are younger cloggers around, like Phil Howarth of Stockport, no one else is mending or making clogs in Bolton anymore. 'It's a bit sad' says Foxy 'there's no one around to discuss how you do things'.

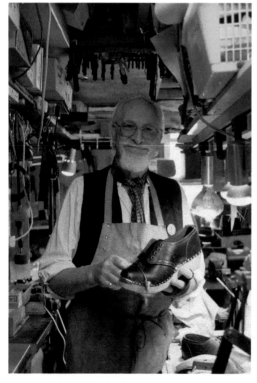

Foxy and a clog.

G

G-AICS (BL6 6SL)

On 6 February 1958 twenty-three people died when a British European Airways Tudor crashed in Munich. This is remembered because eight of the dead played football for Manchester United. No one remembers what happened three weeks later when thirty-five people died on Winter Hill when a Silver City Bristol Wayfarer crashed – the dead were only car dealers from the Isle of Man. The weather in Man on take-off that morning had been clear, but a snowstorm cut visibility to zero once the plane reached the Lancashire coast. Navigation was by radio beacon, which the plane followed, changing the direction as each beacon was reached. On reaching Blackpool the co-pilot, William Howarth, typed in the number of the wrong beacon, sending the plane not towards Wigan, avoiding high ground, but towards Oldham, with Winter Hill in its path. The scheduled altitude was 1,500 feet, which might have been fine as Winter Hill is 1,496 feet at its highest. The Oldham beacon took the plane down the Belmont Valley, which the Zone Control Officer in Manchester noted on his radar plot. He saw that G-AICS was too far east and, alarmed about the high ground around the plane, instructed the pilot, Mike Cairns, to turn south – inadvertently guiding the plane into Winter Hill.

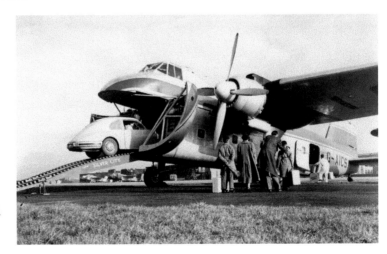

G-AICS, the Silver City Wayfarer. (Courtesy of Bristol Aircraft via A. J. Jackson collection)

G-AICS crashed just below the communication towers. (Courtesy of Julia Uttley)

The Wayfarer, in zero visibility, clipped the final slope at 170 miles an hour and cartwheeled over. The fuselage was destroyed. All seven survivors were in the cockpit or aft in the plane. By good fortune the crash site was only 200 yards from the newly opened TV transmitting station on Winter Hill's summit. The storm was so bad none of the staff working in the control hut heard anything, so when the co-pilot, injured, stumbled in and said there had been an accident, the men there wondered how he had driven up the hill in the storm. Once they understood the nature of the crash their telephone call summoned help immediately, though it took hours for rescue vehicles and ambulances to fight their way to the summit.

Greenhalgh, Shaun (BL1 1SE)

Bolton has produced a decent crop of artists, although most moved away to pursue their trade. Thomas Cole and Thomas Moran both emigrated to America to find fame. Alfred Heaton Cooper made his family's reputation in the Lakes and Brian Bradshaw did most of his work in South Africa. Francoise Taylor did her significant work in Bolton, but was Belgian. Denis McLoughlin, though, arguably the finest ever British comic illustrator, never left Bolton. Roger Hampson, who painted evocative industrial scenes, stayed around and Nigel Artingstall, internationally renowned wildlife artist, lives and works in Harwood. Bolton's most famous artist currently lives here, but is well known for the wrong reasons.

Shaun Greenhalgh, born in 1960, has produced watercolours, sculptures, ceramics, stone and metalwork. From around 1990 he sold some of his own pieces as the work of

well-known artists, often using his father George as the salesman. In this fraudulent scheme Shaun's dad acted the untutored northern mark, convincing some dealers that they were conning George rather than the opposite. Shaun's most notorious sale was of the foot-high calcite statue he had carved in three weeks. Bolton Museum paid £440,000 for it after the British Museum had pronounced the piece authentic, recognising it as the 3,300-year-old Egyptian Amarna princess 'lost' 200 years before.

In the end, mistakes on an Assyrian relief carving encouraged the British Museum, Sotheby's, Christies and Bonham's to share their suspicions of Shaun and his father, revealing a pattern of dubious activity over several years. The police called at their Bromley Cross home and found a workshop and a number of suspicious items. The subsequent 2007 trial focussed on forty forgeries and resulted in Shaun being sentenced to four years and eight months in prison.

After the trial the national press poured scorn on the quality of Shaun's work, the garden shed he was supposed to have worked in and the shabbiness of the family home. Even Shaun buying DIY equipment at B&Q was ridiculed, as if there are special hardware stores for art forgers.

On his release Shaun confronted his shame and continued his art, selling pieces under his own name. And now the crimes are long gone a new attitude is developing. Looking at what he does, the skill shown across a vast range of methods, materials and styles is remarkable. He has had a go at everything from ornamental metalwork to ceramics, watercolour, oils and carving in wood, alabaster and marble. Shaun Greenhalgh, is, to coin a new word, a Polyfex. He can make anything. We should cherish him.

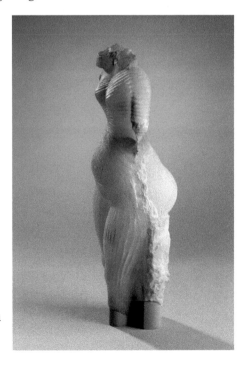

The Amarna Princess. (© Bolton Council. From the Collection of Bolton Library and Museum Services)

Haulgh Hall (BL2 1JG)

Haulgh Hall, on Hilden Street, was built in 1602, perhaps earlier. It vies with one of the Firwood Fold houses for being the oldest inhabited dwelling in town. The hall passed to Orlando Bridgeman from the Haulgh family in 1639 and then to his descendants, the earls of Bradford. Just over a century ago Haulgh Hall was bought by Bolton Council. By that time the art college was next door and Bridgeman Park was close by – an ancient house in a modern urban scene. Between 1912 and 1982 the Bradshaw family were tenants. Old Sam Bradshaw was a professor of music and his son Hubert was a flyer in the First World War who subsequently ran John Wild's bolt stamp-making company, the last of its type in Bolton. Sam's grandson, Brian, born in 1923, became a distinguished artist and chair of fine arts at Rhodes University in South Africa.

But the last decades of that tenancy were frustrating for the family. The Bradshaws had maintained Haulgh Hall as best they could while the council carried out minimal

Haulgh Hall.

repairs. By 1960 it was tattered and decrepit. Some on the council wanted it pulled down as it was 'a shippon' (cow barn), while others, like Harry Lucas, championed its value to the town, pointing out how much had been lost of Bolton's architectural heritage. Much is said about the disappearance of mills in Bolton but Tudor, Jacobean and later houses have gone too. Arkwright's barbershop at No. 15 Churchgate went over a hundred years ago. Bradshaw Hall has gone and the Ainsworth family's Moss Bank House. Hacken Hall, Darcy Lever Old Hall, Breightmet Hall, Thicketford House, Egerton Hall, Hulton Hall, Darley Hall in Farnworth and Great Lever Hall have all gone. Ashworth's house, the Oaks, has gone as has Brynmoor, Burnthwaite and Brooklyn. Halliwell Hall on Church Road and Sharples Hall (previously Ollerton) are still there but have been split into flats. Farnworth's Rock Hall is still there, just, but Birtenshaw Old Hall in Bromley Cross, another Ashworth home, was demolished recently.

Surveys, investigations and hand wringing about Haulgh Hall followed, but it took twenty years for the council to find the will for a comprehensive refurbishment. This was completed in 1982, but the work had been accompanied by several break-ins and vandalism. Old Hubert George Bradshaw died before he could move back into the oldest council house in Britain.

Today Haulgh Hall is still a home. Inside it is modern and liveable, though the floor is stone flagged and the remains of the tiny chapel inside give an indication of its age. The ancient wooden cruck construction is highlighted outside confirming the existence, in an otherwise ordinary town landscape, of something very special.

High Street Library (BL3 6SZ)

The Public Libraries Act of 1850 encouraged local authorities to build 'free' libraries. Bolton's original central library, established in 1853, was on the corner of the Town Hall square. It was only the 1887 donation from Queen Victoria's Golden Jubilee fund that encouraged boroughs to build more. High Street Library, Daubhill, was one of seventy-seven built in Britain in 1888 and the first branch library in Bolton. The hope was that such services would support the cause of temperance. High Street Library was opened by Alderman Fielding, stocked with 4,500 books, and now in a modern building is still going strong today.

A significant contribution to the public library service in Bolton was made by Scots/American steel magnate, Andrew Carnegie. Of the 660 libraries he funded in the UK four were in Bolton alone – Farnworth, Great Lever, Halliwell and Astley Bridge.

Later in 1938 the Town Hall extension project included the building of the impressive library, museum, art gallery and aquarium complex on Le Mans Crescent. A grand neo-Georgian, curved sweep of Portland stone, Le Mans Crescent is stunning. Today it has a national profile. Though never named, it appears as the backdrop to street scenes in countless films and TV dramas.

Above: High Street library.

Left: Central Library, Le Mans Crescent.

Hultons, The (BL5 1BH)

If Bolton had to choose a hate figure it would probably be William Hulton (1787–1864), the man who ordered the militia to break up the crowd at St Peter's Fields, Manchester, on 16 August 1819. Hulton's family had owned hundreds of acres of land 5 miles south-west of Bolton for over 500 years and his standing, at the age of thirty-two, was such that he was appointed to chair the Cheshire and Lancashire magistrates. This was the basis of his authority to give the order for the Peterloo Massacre.

He already had a reputation for cruelty. Legend has it that he, as High Sherriff of Lancashire, sanctioned the hanging of twelve-year-old Abraham Charlson, an invalid crying for his mother as he went to the scaffold. The little lad, who only smashed a

Hulton Hall. (© Bolton Council. From the Collection of Bolton Library and Museum Services)

window, was one among several hanged that day – a harsh response to machine breakers who had burnt down Westhoughton Mill in March 1812. It could be argued that Hulton only behaved as other landowners of the day would have and recent scholarship suggests that Charlson was closer to eighteen, an active participant in the arson and no invalid. Does that exonerate William Hulton or should we still regard him as a monster?

The other side of his personality was as a progressive industrialist. Hulton employed George Stephenson to build the Bolton/Leigh railway line in 1828, one of the first public railway systems in the world. This allowed Hulton's coals to be transported into Bolton easily and cheaply, literally fuelling the burgeoning cotton industry.

Coal made the Hultons ever wealthier and William paid the lowest wages in Lancashire, reluctantly giving up payment of his colliers by voucher redeemable only at his shop when it became illegal. He fiercely opposed unionisation, but, again, was he that different from other mine owners? His descendants were said to have been generous to the survivors of the explosion in the Pretoria Pit complex on 21 December 1910, which caused the deaths of 344 men. Although Pretoria was the third-worst-ever pit disaster in Britain, even this horror did not lead to any marked change in safety procedures. The whole country was shocked at the loss, though, and £145,000 was raised to support the survivors and their families. Payments from the fund continued until the last beneficiary, John Baxter, died in 1973.

Now everything associated with the Hultons is gone. Hulton Hall was demolished in 1958. No pits survive, nor the railway and even the family line died out with unmarried Geoffrey Hulton in 1993. He was a different type of fellow from forebear William. Geoffrey was a philanthropist, actively involved in Scouting all his life and one of the many Bolton men who suffered three years in a Japanese prisoner of war camp.

Left: The Hulton Memorial in Deane churchyard.

Below: Pretoria pit rescue workers. (© Bolton Council. From the Collection of Bolton Library and Museum Services)

There is one subtle legacy. Julian Fellowes, himself a Hulton descendant, remembers Hulton Hall and the staff there. And who knows, some of those people may have reappeared in Fellowes' creations Gosforth Park, Downton Abbey and Belgravia.

I

Institute for Materials Research and Innovation at the University of Bolton (BL3 6HQ)

The remaining chimneys and mill buildings are not the only survivals of textiles in Bolton. The town's further and higher educational framework derived directly from the industry. This started with the Mechanics Institute, established in 1825, which by the end of that century had become a technical school, then in 1926 a technical college. While this side of education supported the engineering expertise so important to the town, the equally important textile design arm of the industry was supported by Hilden Street Art College.

Mechanics Institute Building, Mawdsley Street.

As mills began to close colleges merged to form the Institute of Higher Education, the textile department being the biggest in Lancashire. Students from the industry itself were attracted to Bolton, experienced people who came not only with questions, but also ideas. Such expertise on hand attracted funding from industry for post graduate study and research and the Institute for Materials Research and Innovation (IMRI) was created. Led by the ambitious and enquiring minds of Dick Horrocks, John Ebdon, Subhash Anand and Baljindar Kandola, IMRI embraced research on non-woven fabrics, composites and geo-textiles. These strange words underpin research, discovery and development in health materials, fire retardant products, even in motor, aeronautical and civil engineering. Such work focusses on protective clothing, vehicle interiors, aeroplane construction, building laminates and smart bandaging. These materials are safe, strong or absorbent, pliable or tough, magical almost, which we rely on but take completely for granted because they are used in familiar items such as car seats, bandages, nappies and workwear.

The institute became the University of Bolton in 2005, welcomed and chided in equal measure. Economically and culturally, it has been a boon to Bolton and IMRI is a top-drawer research facility. However, as the university's future has to balance the appetite for student numbers and quality of teaching with the demands of enthusiastic researchers, compromises have to be made. Moreover, with no national industrial strategy, the niche trade in technological textiles, though worth £9 billion a year, has its work cut out attracting students to what many regard as a dead industry.

University of Bolton, Chancellor's Building.

J

Jam Pot Alley (BL1 4PA)

During the Second World War Chorley New Road was called Jam Pot Alley by some, a comment on the availability on every breakfast table of that particular preserve, which was in short supply elsewhere.

Even though many of the mansions from the foot of Chorley Old Road out to the Beehive in Horwich are now flats, nursing homes and even schools, it is still the prestige place to live in Bolton. In the mid-1800s, as mill owners grew rich, some built big houses on St Georges Road or Higher Bridge Street or in the Haulgh, but they were quickly surrounded by the grit of industry. Later industrialists noticed the straight turnpike road to Horwich, which only had farmland either side and where the prevailing westerly wind drove any smoke to the other end of town. From 1870 expansive terraces were built near the Infirmary, site of Bolton Hospice now, and soon mansions sprang up either side of Chorley New Road far and away to the west.

By 1900 the tram service 'N' (Chorley New Road) trundled sedately along the tree-lined boulevard passing near the homes of William Lever at Hillside, James Musgrave (Atlas Mills) at Knowlsey Grange, James Scott (Provincial Insurance) at Beech House, the Makants (bleachers) at Gilnow Lodge and Percival Haslam (spinner) at Ravenswood. Scores of these grand houses still exude wealth, with jam and more exotic fare no doubt on their breakfast tables.

Chorley
New Road.

Kenny, Jason (BL3 5BN)

Jason Kenny has won seven Olympic Gold Medals, the greatest number of any UK Olympic competitor and the third-highest number of any athlete since 2000 (after Usain Bolt and Michael Phelps). A sprint cyclist, his medals have come from both individual and team events at the Beijing, London, Rio and Tokyo Games. Jason is from Farnworth and, like Peter Kay, attended Mount St Joseph's School. In the fizz of celebration after he won his medals in 2012 a postbox was painted gold on Churchgate and still glows today. A more substantial legacy is Bolton One, the Jason Kenny Centre, a large health and leisure complex right in the centre of town.

Above: Jason Kenny Centre.

Left: Golden postbox, Churchgate.

L

Lads and Girls Club (BL1 4AG)

In 1889 a youth club for boys was opened in Bark Street and immediately attracted hundreds. It was a time when temperance was a powerful force and sports, social clubs and bands were set up to offer an alternative to the pub. Bolton Lads Club opened every evening, offered a range of strenuous games, a reading room and military drill, but also, because these were poor boys, facilities for washing and eating. On the back of an increasing interest in the outdoors, boys were also taken on weekend and summer camps. At first volunteers alone ran the club – middle-class men, including the likes of Dr John Johnston and Fred Wild, members of the literary Whitmanite group.

Funded today by many donors (including the profit from the prestigious Bolton Beer Festival) the Lads and Girls Club sits at the heart of Bolton's youth provision, absorbing support from a range of sources. It has 4,000 members and with seven-day opening the Lads and Girls Club offers young people a vast assortment of activities: thirty-two different sports, drama and dance, holiday clubs, mentoring, outreach work and more. Tens of thousands of young people have benefitted in so many ways from the Lads and Girls, the highest profile being the footballer Paul Moulden and boxing champion Amir Khan.

Lads and Girls Club.

Lever, William (BL6 7SA)

William Lever's humble birthplace in 1851, a terrace in Wood Street, is well known, but his father James had a successful wholesale grocery business that enabled the family to move to the infinitely grander Harwood Lodge when William was a young man. So William had a start in wholesale, but his fortune derived from his dynamism, attention to detail and his key invention, Sunlight Soap. Cheap to produce from vegetable oils rather than tallow, Sunlight's key feature was the attractive and innovative wrapping – mass produced but looking like a personal gift. Sunlight, like Kellogg's Corn Flakes and Cadbury's chocolate, launched around the same time, was cleverly marketed and became, for a long moment, a universally trusted brand. Lever was a clever organiser, seeing business opportunities everywhere, but most of all he made marketing the basis of his business. He used increasing working-class spending power and the national newspaper boom powered by advertising to ride to riches.

Lever went on to build a vast industrial complex, supplied by raw materials such as palm oil from plantations across the world. Criticism for the deforestation caused and the use of indentured labour and much worse in Africa and the Pacific islands was muted at the time. Today Lever's commercial legacy, the Dutch/British giant Unilever, which makes everything from bleach to mustard, is regarded by many as being at the forefront of sustainable production.

Lever was a philanthropist too. He funded schools, the university in Liverpool and the art gallery and workers' cottages at Port Sunlight. He also bought the Isle of Lewis and built an entire village there – Leverburgh. His donations to Bolton life

Harwood Lodge today.

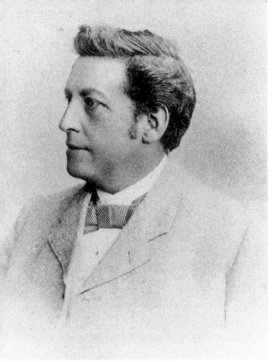

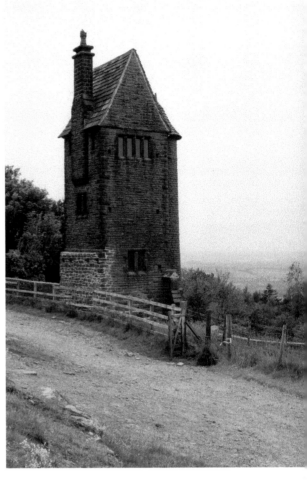

Above: Lever as a young man. (© Bolton Council. From the Collection of Bolton Library and Museum Services)

Right: The Pigeon Tower, Rivington Terraced Gardens.

were more practical, however. Lord Leverhulme, as he was from 1917, funded and designed Rivington Terraced Garden, saved Hall I'th Wood from ruin and gave what is now Leverhulme Park to Bolton Council. He re-endowed Bolton School, effecting the merger with the Girls Grammar School, and funded the imposing 1920s building as well as offering educational scholarships.

Lion, The (BL1 4PE)

On 4 September 1939, fourteen-year-old Nat Lofthouse turned up at Burnden Park to sign for Bolton Wanderers. Not the most auspicious time, perhaps, the day after war was declared. The whole of the football club's first team had joined up as a result of a promise made by team captain Harry Goslin in April. For Lofthouse this was a boon. With senior players away he broke into the first team at an early age. Although he spent some time as a Bevin Boy collier before 1945, by the time professional football resumed in 1946 he was a seasoned player.

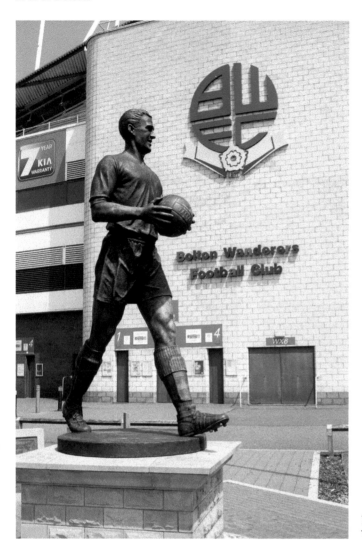

Nat Lofthouse at
Wanderers' stadium.

Lofthouse is one of that breed of professional players who played for one club only –
captain, goal scorer, talisman, gentleman. He played 452 times for the Wanderers and
scored 255 goals. Owing to the war his start for England came when he was already
twenty-five. Nevertheless, he racked up thirty-three caps in an age when there were
few international matches, scoring thirty times, a goal a game. It was in one of those
games that he earned his nickname. In a hard-fought game in Vienna against Austria,
Lofthouse was bashed and clattered and still managed to score the winner. Forever
afterwards he was the Lion of Vienna.

M

Man and Scythe (BL1 1HL)

Much is written about the Man and Scythe. First recorded in 1251, this pub is accepted as one of the six oldest pubs in the country. Owned in turn by the Ferrers family, the Pilkingtons and then the Stanleys, the building on the Man and Scythe site has been a pub without interruption for 800 years. Eccentric landlords, ghost sightings and the famous execution of James, 7th Early of Derby fill guide books and the dark, low interior could not be better suited to haunting tales. Today though the pub is renowned locally for music nights when everyone is welcome and the 'Cider 'ouse', as it is known, has recently revived the gruesome ritual commemoration of the beheading of James Stanley each October.

But the stories are not just from the deep past. In the early 1960s a duo called Tom and Jerry played in the back room, a couple of American folk singers. No one knew

Man and Scythe.

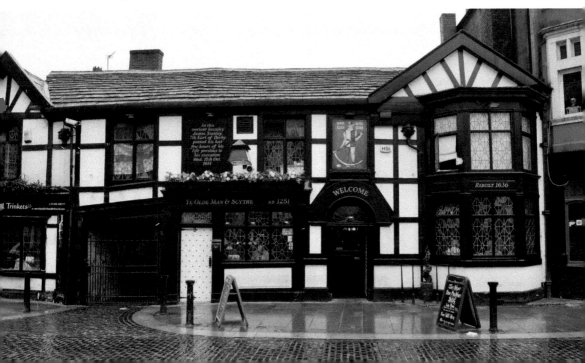

Lu Pingyuan, where's our ghost? (Courtesy of Layla Hu, MadeIn Gallery, Shanghai)

who they were. It was only later locals put two and two together. Once back in the USA Tom and Jerry reverted to their real names, Simon and Garfunkel.

Perhaps the oddest story of all took place in 2015. That summer a Chinese artist, Lu Pingyuan, had an exhibition in Manchester's Chinatown. A conceptual artist rather than a maker of artefacts, Lu was intrigued by the 2014 YouTube image of a 'ghost' captured by a security camera at night in the Man and Scythe. He visited the pub and without disclosing his mission secreted himself in a toilet. There he confronted, seized, and, there is no other word for it, 'bottled' James Stanley's ghost. The screw-top metal container with the ghost inside was then shown at the exhibition in Manchester with no 'by your leave' sought or obtained. The container is now in Shanghai. Can we have our ghost back?

Marsh, George (BL1 7NP)

George Marsh was born and lived most of his life as a farmer in the parish of Deane, near Bolton. A great change occurred after the death of his wife in 1540. He left his children in the care of his parents and entered Cambridge University. Lancashire at the time was a traditional Catholic stronghold, unmoved by the Protestant ferment in London. At Cambridge, though, Marsh became an avowed reformer, following a renowned preacher named Lawrence Saunders. Ordained in 1552 during the

Protestant reign of Edward VI, he served in Leicestershire and then All Hallows, Bread Street, London. But 1553 changed everything as the new queen, Mary, reversed the religious direction. Religion at the time was as much a function of State control as a matter of conscience, so you worshipped as directed or paid the price. Poor George Marsh, imposing figure and popular preacher though he was, had to decide whether to bend his opinions to the new regime or stand by his beliefs. His mentor Saunders was arrested in 1554 and George Marsh retreated north, back home to Deane.

Most priests followed the ebb and flow of the doctrinal tide, preaching whatever was prescribed. George Marsh though was principled and stubborn – saintly or stupid, take your pick. He retreated physically, but continued to preach that the Bible was the source of truth, and spoke out against what he saw as the obfuscating flummery of Catholic dogma. George, an insignificant figure himself but associated with notorious Protestants, was seen as a threat. Edward Stanley, 3rd Earl of Derby, Mary's Lord High Steward but with Lancashire roots, ordered George's arrest. When he discovered he was being sought by local justice Sir Roger Barton, Marsh was bold enough to present himself at Smithills Hall. Barton accused him of being 'a bitter and foul-mouthed protestant', a sure sign Marsh got under Barton's skin.

Marsh was then interrogated at Lathom House by Stanley himself, held in Lancaster Castle for a year and eventually tried at Chester Cathedral for heresy. Time and again he was offered a way out, right up to the lighting of his execution pyre. He refused. He died on 24 April 1556. Mary had 300 Protestants burned, but George Marsh and Yorkshireman John Snell were the only northerners to suffer that fate.

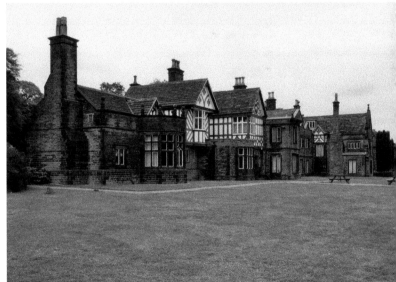

Above left: Deane Church Cross.

Above right: Smithill's Hall.

Bolton has two physical memories of George Marsh: the memorial at Deane Church and his footprint at Smithills Hall. It is said that during his interrogation by Barton, George's wrath was roused and in a fury of religious righteousness he stamped his foot so hard the shape of it remains to this day in the stone.

Moulden, Paul (BL2 6DD)

A mile out of town along Bury Road is a chip shop named Paul's Chippy, and until 2021 it was run by Paul Moulden. Paul is an amiable fellow, unlikely to mention his background as a professional footballer with Manchester City, Birmingham City and other teams. But his real claim to fame predates his free scoring professional career cut short early by an ankle kicked beyond use at twenty-nine. As a fifteen-year-old, Paul played in a very good Lads and Girls Club team, which contained several players who would move onto professional careers. He was called up to the England youth squad and played at Wembley, scoring goals for fun along the way. A friend of his father's, uncle Joe, was a football statistician. Joe was impressed by Paul's prowess, so he counted the goals, double checked, spoke to referees and totted up his account. The number of goals Paul scored in an official FA registered team in formal refereed games in the 1981/82 season was a record. It is a record still: 289 goals in one season. Some say 340, but that's pushing it a bit.

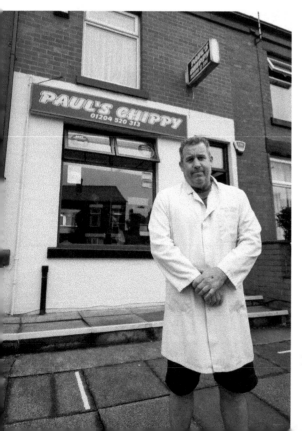

Paul and his former chippy.

N

Naughton, Bill (BL1 1SE)

Bill Naughton is Bolton's most celebrated writer. Three films were made about his most famous character, Alfie, and there are regular revivals across the UK of his plays *The Family Way* and *Spring and Port Wine*, both also filmed. Born in County Mayo, four-year-old Bill came to Bolton in 1914 with his mother Maria to join his father who worked at Brackley Pit. They lived in Unsworth Street, Daubhill, and when Bill and Annie Wilcock married they moved in with her parents in Rawsthorne Street, Halliwell, before settling in a council house in Johnson Fold. Through the 1930s Bill was employed as a Co-op coal delivery driver.

Renowned for the accuracy of his portrayals of working-class Bolton life, Naughton started writing when he was twenty-eight: a journal, which he kept up for the rest of his life. He saw possibilities of life beyond the town through his volunteering for the Mass Observation survey of Bolton life in 1938, then spent the war in London

Bill with his wife Erna at the height of his success. (Courtesy of Jan O'Brien)

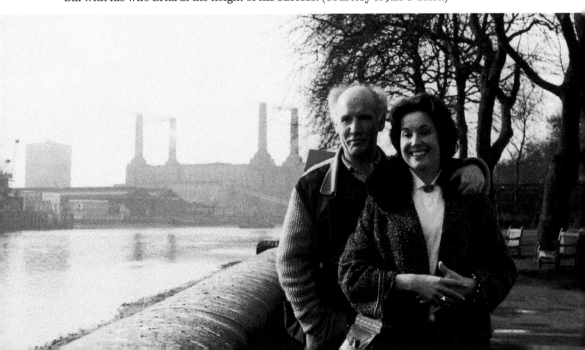

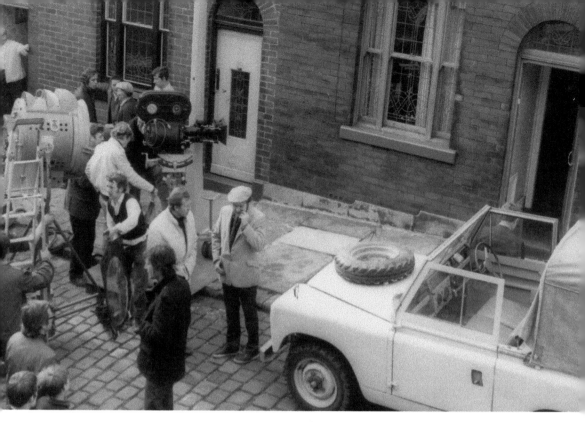

Filming *Spring and Port Wine*, 1969. (Courtesy of Stewart Ball)

as a civil defence driver. He started writing short stories and soon was offered a contract for a novel. He hit the big time in the early 1960s when his pal Bernard Miles promoted three of his plays at the Mermaid Theatre, London, all of which moved to the West End.

Unfortunately, very little survives of the Derby Street Naughton inhabited as a young man and wrote about later, but the Central Library holds a huge archive of his work, including the 300 notebooks that contain half a century's worth of entries in his daily journal.

But there is another legacy. Just as Naughton left London to settle on the Isle of Man his play *Spring and Port Wine* was being filmed. Wisely, the producers chose Bolton as the location for all the outside shots. The film has been described as a 'time capsule' as the images of the town captured in 1969 display the spirit of the place, just as modernisation and mill closures were about to change it forever.

O

Octagon Theatre (BL1 2AL)

In 1800 Bolton's Old Theatre on Mawdsley Street, with a middle-class clientele, was thriving. However, people working in mills, many more of them as the century unfolded, demanded more animated, lusty entertainment. To meet this need Thomas Sharples opened his Star Concert Room at the Millstone in Deansgate in 1832, moving to Churchgate in 1840. This vast, elaborate palace of diversion burned down in 1852 but was replaced by the Theatre Royal. In Dawes Street, a rival appeared: the Temple Opera House. This held up to 6,000 people, but as the Temple, like other such halls, was a cheap wooden construction, that too was consumed by fire. By 1910 three grand theatres were operating: The Theatre Royal and The Grand on Churchgate and the Hippodrome on Deansgate. In 1934 Bolton Little Theatre opened, where Sir Ian McKellen started his career, and in 1948 this was joined by Farnworth Little Theatre.

Then TV came along. The amateur theatres survived but, in a two-year period in the early 1960s, the professional theatres closed – a serious blow to Bolton's self-regard. The council, mindful of this cultural deficit, set aside both land and funding to put this right. But the plan for a big civic theatre was vague and nothing was happening

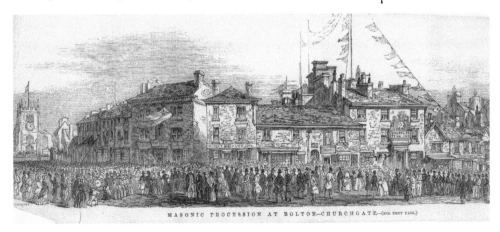

MASONIC PROCESSION AT BOLTON—CHURCHGATE.—(SEE NEXT PAGE.)

The Star Inn, 1840. (© Bolton Council. From the Collection of Bolton Library and Museum Services)

when, out of the blue, four drama students from Loughborough got in touch. They had urged their lecturer, Robin Pemberton Billing, to approach the council with a radical plan. This was for a small, flexible theatre that could operate not only in traditional proscenium arch style, but also as a theatre in the round or one with a thrust stage. At that time, there was nothing like this in Britain, or Europe for that matter. Luckily again, the leader of the council was Harry Lucas, an offbeat Labour man, part-time mountain climber, watercolour collector and determined champion of the arts. He badgered the council into accepting and part-funding the plan, secured an Arts Council grant and squeezed Bolton's philanthropic spirit. The Octagon Theatre opened in November 1967, eighteen months after the plan was first proposed. Pemberton Billing, known to all as PB, was appointed as the Artistic Director.

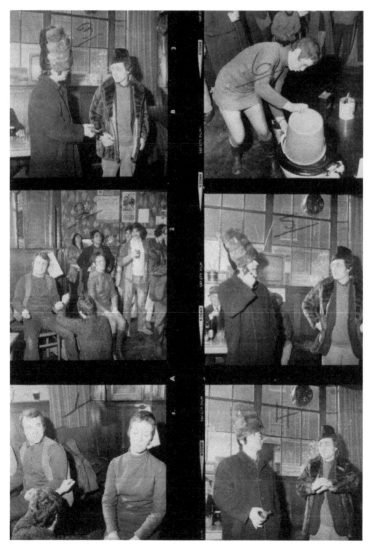

Ken Campbell's Roadshow. Bob Hoskins, Jane Wood and Bernard Wrigley descend on the Wheatsheaf. (Courtesy of Bernard Wrigley and Jane Wood)

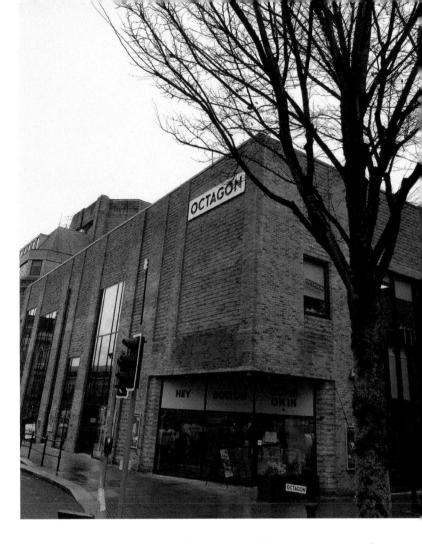

Octagon Theatre.

 PB set out to make sure the Octagon became a vibrant part of the community, with its bar and restaurant, educational outreach programmes and use of local talent. Alison Steadman, Robert Powell, Danny Boyle and Maxine Peake all got a start at the Octagon. But the radicalism is best demonstrated by the way the Octagon Roadshow operated. Ken Campbell, actor, writer, enthusiast and eccentric was put in charge of a bunch of young actors who went out into town putting on reviews and sketch shows. Some were planned but on occasion they just turned up in pubs and performed. Ken took umbrage when he thought the Octagon trustees were not supporting the roadshow and complained loudly. Unsurprisingly, he and his troupe were sent packing and the radical, 1960s edge dissipated. Today, though, the Octagon, which over the years has had a series of talented artistic directors, is revered across town and the North West, putting on classics as well as producing a regular stream of local work. Recently refurbished the 'new' Octagon is set to wow audiences for years to some.

Parish Church of St Peter's (BL1 1PS)

There has been a church sitting high above the Croal for at least a thousand years. The Saxon coffin and cross in St Peter's main entrance is proof enough of that. The site of a parish church since the Middle Ages, the 1871 building is a fine example of Victorian Gothic, and it has the highest tower of any in the old county of Lancashire. The pulpit and north window are remnants of the previous building. The interior is spacious, an impression enhanced by the pale sandstone and carefully spaced pews. Like many other buildings in town the exterior was sandblasted in 1969, turning black into light gold. Chillingly, the interior had been nearly as soot covered as the outside.

Like any town centre church, the great and the good fill the cemetery, including Samuel Crompton, and regimental flags and memorials fill the walls – reminders of

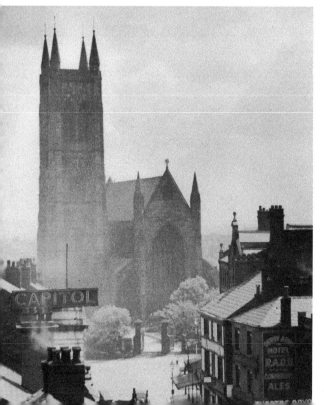

St Peter's Church, 1939. (© Bolton Council. From the Collection of Bolton Library and Museum Services)

lives well lived and lives cut short. A special feature is a large marble plaque listing all the dead from the Boer War. Previously, war memorials had included the names of regiments or notable officers, but no ordinary soldiers. This honouring of private soldiers in 1904 along with their 'betters' was new.

Another poignant feature relates to Thomas Chapman, the vicar of Bolton in 1914. In those febrile days, the height of the suffrage movement, Chapman had a run in with a woman called Florence Geldard. She wrote to the vicar in June 1914 asking that a prayer be said for those suffragettes in prison, by that stage subject to force feeding to break hunger strikes. The vicar did not reply, so Florence, attending a service, stood during the collect and, in a nervous voice, read a brief prayer. She then left with her friends. Arthur Wild, the warden, followed her with a police officer. She was arrested and charged. Only when the case came to court did the vicar say he would present no evidence – a tantalising cruelty masked as an act of charity.

So, Chapman was a supporter of the status quo but also a family man. He and his wife had three children, a daughter and two sons, both of whom went to war. Alfred Chapman died in 1916 a lieutenant in the Lancashire Loyals. He was twenty. His brother Cecil died too, in 1918 at the age of seventeen. Their memorial takes the form of beautiful stained-glass windows, with one of the brothers represented as Saint George and the other as Saint Michael. Side by side, gaily clad, when the light catches them their images blaze brightly, bringing the two boys momentarily back to life.

St Peter's Church today.

Phoenix Club, The (BL4 8AG)

Peter Kay is a purveyor of observational comedy at its most acute. Half the time he affects a naive and clichéd northern view of the world, an urban bumpkin, but manages to reflect the experience of any audience. He engages people by highlighting the absurd in everyday life: changing light bulbs, behaviour at weddings, watching TV. Comedy, as he says, is a mirror. His comedy sometimes identifies ridiculous characters or circumstances (Potter or Max and Paddy from Phoenix Nights) but as often he picks on foibles many of us have. He gets us laughing at him, and through that we laugh at ourselves. He still holds the record for the most successful comedy tour of all time in 2011 when 1.2 million people saw him perform in one of that tour's 140 shows. Much loved locally, he was born and brought up in Daubhill and still lives locally. His breakthrough TV series *Phoenix Nights*, written with Dave Spikey and Neil Fitzmaurice, features St Gregory's social club in Farnworth.

Peter Kay. (Courtesy of Nick Harrisson)

St Gregory's Farnworth, the Phoenix Club.

Queen's Park (BL1 4RU)

Before young people had access to cars, if a couple's desire went beyond the capacity of the double seats on the back row of local cinemas, Bolton boys and girls repaired to Queen's Park. The 22-acre site was opened by Lord Bradford in 1866, near Spaw Road, as it was then called, where the existence of pump houses suggests the area was already associated with leisure. The park was immediately popular. Bands played, concerts were held, gatherings arranged and in 1897 the park was renamed after the old queen. The site of many a family day out, celebrations, summer concerts, parades, promenade performances and possibly the site of Freddy Mercury's first public gig, Queen's Park has always been a draw for courting couples.

Queen's Park.

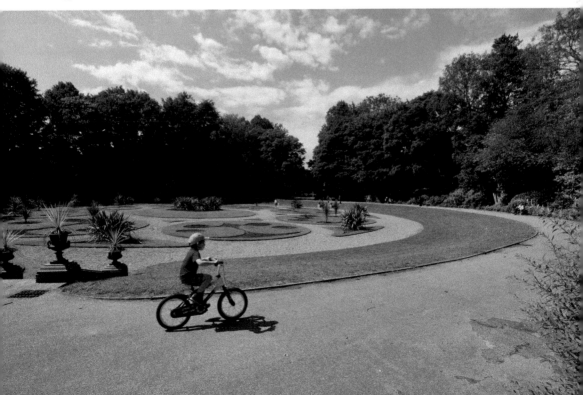

During the First World War the freedom afforded young, female munition workers, along with the demise of a chaperonage for middle-class single ladies, led to worries that free-spirited girls might be tempted to sin with one of the thousands of young men in uniform who were everywhere. Many towns set up women's patrols to watch for lapses in morality. Bolton did not do that, but instead established a Women's Section in the local constabulary in 1919. This consisted of four female officers and a sergeant, Ethel Jeeps, and although childcare duties and escorting female prisoners was part of their job, their most pressing work was to prevent moral lapses. Queen's Park was at the heart of the Women's Section's patrols, and very effective they were too. The annual police report of 1924 noted that in the previous year 733 couples seen in compromising circumstances had been approached, convinced of the dangers of public canoodling and dissuaded from continuing.

Bolton's Women Police, 1919. (© Bolton Council. From the Collection of Bolton Library and Museum Services)

R

Rostron, Sir Arthur (BL1 7AB)

Cunard's liner *Carpathia*, captained by Arthur Rostron, and Leyland Line's *Californian*, a merchantman with Stanley Lord in command, had a lot in common. The former, built in Dundee, was launched in 1901. The latter was built in Newcastle in 1902. Both were sunk by German U-boats in the First World War. And, famously, they were both in the same vicinity in the Atlantic on the night of 15 April 1912 – Lat 41. 46' N., Long 50. 14' W.

Just after midnight, Stanley Lord's lookouts saw rockets from a giant liner nearby, but decided they were part of some entertainment and stayed hove to, a precaution against the icebergs all around. Similarly, Rostron's officers, when alerted by a wireless distress call, could not believe the *Titanic* was in danger. But Rostron overrode his doubters and sped 60 miles to the spot, arriving less than two hours after the *Titanic* sank. He shut off the heating and power throughout the *Carpathia* to raise the speed to 17 knots from the customary 14, dodging icebergs all the way. He made sure the three lounges were ready with soup, blankets and three doctors on hand – the Hungarian doctor in the third-class lounge, an Italian in the second and a proper English doctor for first-class passengers.

And what has any of this got to do with Bolton? Well, Lord and Rostron were born here, barely 2 miles apart: Stanley Lord in Hampden Street in 1877 and Arthur Rostron in Sharples eight years earlier. Rostron's father was a dye works manager, but young Arthur chose the rigours of the sea rather than follow his father into cotton industry management.

Stanley Lord, who lived until 1962, spent his life trying to justify his decision to do nothing that night. Rostron, on the other hand, was hailed a hero for his actions. He then had an eventful war, first captaining the Lusitania. Later he commanded a troop carrier and hospital ship off Cape Hellas on 25 April 1915, the first day of the Gallipoli campaign. That ship was Cunard's *Mauretania*, a prestigious command, which after the war reverted to ferrying the grand figures of the day to America in Ritzy style: Churchill, Ramsay McDonald, Gracie Fields. Rostron kept that command for ten years, claiming the Blue Riband with the *Mauretania*, the much-prized accolade for the fastest Atlantic crossing.

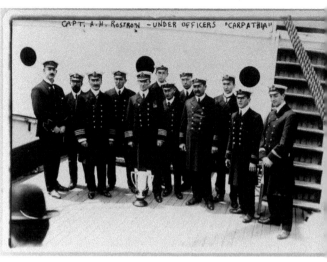

Above: Arthur Rostron and officers on the *Carpathia*. (Courtesy of Library of Congress)

Left: No. 709 Blackburn Road, Astley Bridge.

Rounders (BL1 6RH)

Amateur sport for men has always been a notable feature of life here. The Bolton and District Cricket Association, for instance, established in 1888, is one of the two oldest in the UK. Cricket still has a powerful presence in the town, but women's sport is noteworthy too. For a brief moment during the First World War women's football was the big thing. Bolton's team, though not a patch on the amazing Dick Kerr Ladies of Preston, had a strong following, being run by Eileen Vizard, Wanderers' captain Ted Vizard's wife. A promising future was curtailed when the FA cruelly banned women from all registered grounds in 1921.

A longer-lasting sporting commitment for Bolton women is rounders. Started in elementary schools, Sunday schools and mills before the First World War, it continued to thrive afterwards. A league was first formed in 1922 and has gone from strength to strength. Today there are 128 teams registered with Bolton Sports Federation, which play in thirteen divisions. Each team has eleven players, but squads may be fifteen strong and taking into account coaches, referees and scorers there are approaching 2,500 women and girls involved each summer. The showpiece of the season, the Chadwick cup final, has been played at Heaton Cricket Club in late August for over eighty years.

This longevity and dedication is remarkable as Bolton teams do not play by the national Physical Educational Association rules. By the time these were formulated in the 1920s, Bolton players had their own rules, using a smaller, wide, flat bat and a tennis ball. The scoring system is different too. Bolton chose to ignore the national rules a century ago and live by a more subtle, tactical game than other towns. Debbie Booth, currently secretary of the league, says matches are fiercely competitive but that the Bolton rounders community is like a big family. Generations of women start as children in junior teams and play through their lives into their sixties as 'Golden Girls'.

Bolton's adherence to its unique brand also features another continuity with the past. The players buy their bats from Tobutts of Astley Bridge, which it is claimed, now Whites of Warrington and Knowles of Worcester have closed, is the oldest independent sports shop in Britain.

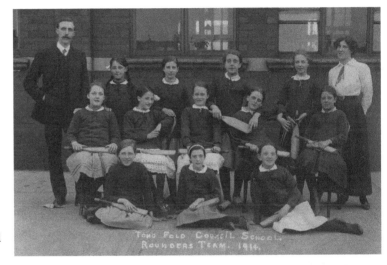

Tonge Fold rounders team 1914 – with Bolton's flat bat. (© Bolton Council. From the Collection of Bolton Library and Museum Services)

Rupert Ladies – Champions 2019. (Courtesy of Debbie Booth)

Spinner's Hall (BL1 2BS)

Built in 1880 as a Reform Club, the Spinner's Hall was bought by the Bolton Operative Cotton Spinners Association in 1886. Through the twentieth century it housed four other trade unions as well. In its heyday, the building's corridors were abuzz with people bringing complaints, planning industrial action, preparing for negotiations, intrigue and secret machinations. In the meeting hall Labour MP Alfred Gill's speech in 1911 was interrupted time and again by suffragettes, all of whom were ejected. Perhaps that identified the Spinners as a target because on Saturday 5 July 1913 a flaming parcel with explosives inside was manoeuvred through the letter box. It failed to ignite but

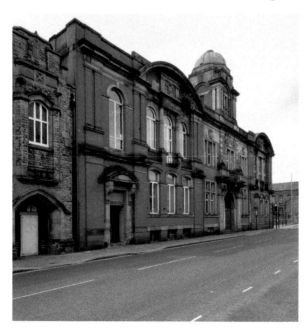

Above left: Spinner's Hall.

Above right: A young Alice Foley (left) at socialist summer camp. (© Bolton Council. From the Collection of Bolton Library and Museum Services)

suffragettes claimed responsibility anyway. This was part of the same arson campaign that included Edith Rigby's attempt to burn down Liverpool Corn Exchange the same day and her successful destruction of William Lever's cottage at Rivington two days later.

The most celebrated union leader who worked at the Spinners was Alice Foley. Alice was employed by the Bolton Weavers, a union whose membership was mostly female, from around 1910. But even though Alice was a powerful presence and force for good – magistrate, mental health campaigner and Workers Educational Association stalwart – she was a woman, and was kept out of the top job until 1948. All political bustle is gone now and today the Spinner's Hall, though still imposing, houses flats, restaurants and other businesses.

Steam Museum (BL1 4EU)

Despite the vast array of machinery that drove Lancashire's cotton industry, few examples now exist. Queen Street Burnley and the Manchester Museum of Science and Industry have power looms and Helmshore Textile Museum has workable spinning mules. Bolton has an original mule made by Crompton, but that's about it. But Bolton does have the Steam Museum – a gem. Housed in what used to be a warehouse for raw cotton, the original site offered to the museum by the Mason family sat within the vast Atlas Mill complex on Chorley Old Road. Although some of the mill buildings still stand around it, today Bolton Steam Museum sits incongruously behind Morrison's supermarket. The museum houses twenty-seven engines, some of them 150 years old, and is managed entirely by volunteers. Many of these engines are operated today by electricity, but occasionally there is true excitement when one or more of the old leviathans is in steam.

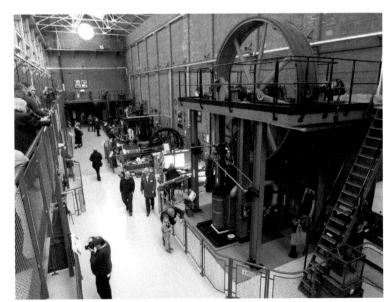

Inside Bolton Steam Museum. (Courtesy of John Phillp, Bolton Steam Museum)

Tum Fowt (BL2 6AN)

Tonge Fold, 'Tum Fowt' to locals, sits in a dip on Bury Road less than a mile out of town. Allegedly, this was where Bolton's first Flemish weavers came, invited by Edward III's Queen, Philippa of Hainault in 1337. This settlement is renowned for a tiny pub, the Park View Tavern, which featured regularly in Allen Clarke's turn-of-the-twentieth-century dialect newspaper *Teddy Ashton's Journal*. Referred to as the Dug 'n Kennel, it was the place where Clarke's comedy creations, Bill and Bet Spriggs, devised hilarious schemes to get one over on their betters, all of which failed dismally.

Clarke, a staunch socialist, also wrote *John o'God's Sending*, a novel featuring the strong Parliamentarian sentiments in the town during the siege of Bolton by Royalists in 1644. So, the traditional commemoration in the Park View tavern of Oak Apple Day cuts across the grain. This celebrates Charles II rather than Cromwell. Young Charles, defeated at the Battle of Worcester in 1653, hid in an oak tree to escape Parliament's forces. In due time Cromwell died and Charles claimed his father's throne. Legend has it that, like Queen Philippa, Charles offered sanctuary to refugees: this time French Huguenots (more weavers) who showed their gratitude in Tonge Fold by setting up an annual fair. On Oak Apple Day a statue of the king was hidden in an oak tree, 'found' and brought back to the pub to be royally toasted. The beery nature of the

The 'Dug 'n Kennel', 1900. (Courtesy of Mark Richardson)

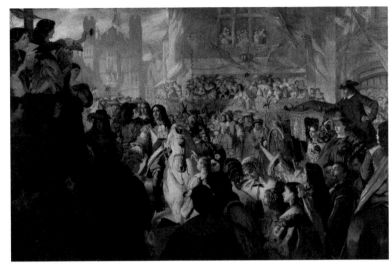

Charles II Entering London by Alfred Barron Clay, Bolton Art Gallery. (© Bolton Council. From the Collection of Bolton Library and Museum Services)

event attracted the attention of a temperance-minded Parliament that abolished the holiday in 1859.

Today the pub is an ordinary house, but the statue sits in Bolton Museum, too hideous to photograph.

Turton (BL7 0HG)

The gullied hillsides of old Turton provided ample water to power a print works, mills and bleachworks. Now although there is Turton school and brooding Turton Heights with its stone circle, the township of Turton is more an idea than a recognisable settlement. A place of no account.

But there is Turton Tower, an extraordinary concoction put together over 700 years. Originally built by the de Torbocs, subsequent owners the Orrells made cruck-framed additions. Then it passed to Humphrey Chetham. He plied a trade in textiles: buying raw cotton in London and selling it in the North West, in turn buying yarn and cloth from local weavers to sell in London. When James Kay bought it in 1835 the Tower was almost derelict. Kay, another local man, made his fortune by inventing the wet spinning process for flax, which industrialised linen production and is still in use today. His refurbishments saved the Tower and gave it that incongruous nineteenth-century Tudor look. And Kay's grandsons, John and Robert, did something else remarkable.

Turton claims a very early tradition of a form of football. The ground in Chapeltown was hosting games as early as 1830. What is reported involved local teams with twenty a side, handling the ball a key part of the game: a formalised version of holiday street melees common everywhere. The difference was that Turton teams played on a flat grass pitch.

Above: Turton Tower.

Below: Chapeltown Football Ground – the oldest in the UK?

Then John and Robert Kay came along, returning from Harrow School bringing a new version of the game. With local teacher Mr Dixon they established Turton Football Club in 1871, said to be the oldest in the North West. Although they still handled the ball initially, Turton adopted modern football rules in 1873. Other local teams appeared soon after, Eagley then Darwen. This caused a sensation locally and Thomas Ogden, teacher in Bolton picked up on it. With Revd Farrell he formed the Christ Church team in 1874, which would in 1878 become Bolton Wanderers. The Turton Tigers today are 150 years old and recently won West Lancashire League's Richardson Cup, adding lustre to their reputation. Visit their ground in Edgworth (BL7 0AE) and the ground at Chapeltown (BL7 0EU), where the Old Boltonians play on what might be claimed as the oldest football ground in the world.

Turton also claims a very well-preserved FW3/24 type wartime pillbox on Chapeltown Road (BL7 0EJ) and reaching up to Turton Heights towards Egerton is Turton Golf Club, which hosts the remains of a Royal Observer Corps underground bunker, used until 1990, designed to record bomb blasts in the event of a nuclear war (BL7 9QD).

So, this forgotten fold in Bolton's edgelands has everything!

FW3/24 pillbox.

U

Under the Clock (BL1 1RU)

Bolton Town Hall may not have the bombast of Manchester or Leeds but vies with Rochdale and Halifax as the very grandest of Victorian buildings. The plan emerged from debate about Bolton, such an important town, needing something splendid to broadcast that importance. After controversy about the cost and design it was finally opened in 1873 by the Prince of Wales. The Town Hall has always aspired to be the heart of the town not just municipal offices. As well as the council chamber, mayor's parlour and reception rooms, the building originally contained a substantial concert

Below left: Bolton Town Hall and a cyclist.

Below right: Bolton Town Hall and gentlemen chatting.

hall, named after Prince Albert, a police court, cells and municipal offices. The clock tower was used by mills and factories, as shift patterns were run on 'Town Hall Time'. God forbid the clock should stop.

Difficult to grasp now but the old metropolitan borough ran everything local: education, policing, electricity, gas, public health and trams. By the 1920s, municipal staff were working cheek by jowl, so it was decided to extend the building and create civic offices spread along an attractive crescent at the rear of the building. Le Mans Crescent was completed in 1938 – a beautiful and much-loved addition to the town.

Under the clock? If you ever spent a night in the police cells, that was where you were, right underneath the clock tower.

Urban Outreach (BL2 1DZ)

Bolton has always been in the vanguard of voluntary effort. One of scores of examples is that of Mary Barnes, a Farnworth philanthropist. In 1905 she was the power behind the establishment of the second 'Guild of Help' in England, a visiting charity whose volunteers were from a diverse range of backgrounds, not just the affluent ladies of Bolton's snooty Poor Protection Society. 'Not Alms but a Friend' was the Guild's motto and soon 400 volunteers were signed up, increasing to a thousand during the First World War. The Guild of Help, though a different service, is still active in Bolton, one of the few survivors of its type. Another trailblazer was Sarah Reddish, ex-weaver, socialist and Poor Law Guardian. In 1911, working with Bolton's Medical Officer, she started the 'School for Mothers and Babies Welcome'. This service, the second maternity clinic in Britain, was a response to the appalling infant mortality in the town. Unused to being offered anything it was surprising that eight working women turned up to that first meeting, but they did, and the idea of advice for new mothers, medical help, free milk and Virol spread like wildfire. 'Babies Welcome' clinics, the forerunner of every maternity clinic in the land, contributed handsomely to a significant improvement in infant health.

Cultural philanthropy was also offered to working people in Bolton when the Court and Alley Concert Society, funded by Lord Leverhulme no less, pitched up unannounced in terraced streets and played classical music to the poor, whether they wanted it or not.

A thriving, and very much needed, successor to these pioneers is Urban Outreach, set up in 1990 by Dave and Chris Bagley. Dave had been a chef but, having achieved success in working at the Athenaeum Club in London, his Christian faith drew him to working with vulnerable children and he came to Bolton. Here he met Christine, a teacher at Crowthorn children's home, whose concern was about the fate of children leaving care. They talked, planned, married, left their jobs and set up Urban Outreach on a metaphorical wing and a literal prayer. At first reliant on gifts, small donations and goodwill the charity supporting troubled young people started in an attic. They soon opened an overnight café moving on to help homeless people and sex workers.

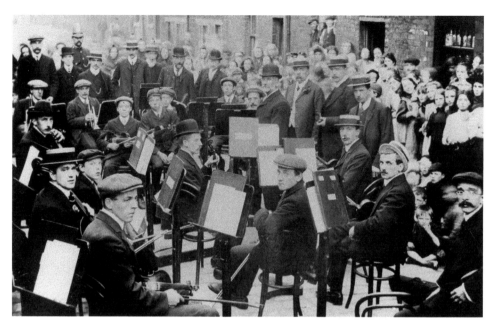

Court and Alley Concert Society. (Courtesy of *Bolton News*)

Urban Outreach.

Today over 250 volunteers help Urban Outreach in their work supporting offenders, the homeless and families. Urban Outreach also has collection points across town supporting an extensive food bank, part of an array of services for those at the edges of – and often shunned by – society. Sourcing and keeping funding is always at a premium, but the charity's success is less about access to money than the determination, passion, faith and optimism that keeps the enterprise going.

V

Victoria Hall (BL1 2AS)

In 1896 Thomas Walker of the tannery family was swept up in Methodism's 'Forward Movement', a radical reaction against staid tradition in worship. Walker put down £5,000 and with that Bolton Methodist Mission decided to create a Central Hall to attract people who never set foot in church. The Victoria Hall opened in 1900 and boasted raked seating not pews, a sweep around gallery, a wide platform rather than a pulpit, front doors at street level and a projection box for showing films. The concert hall itself was so carefully designed that Sir John Barbarolli thought it had the best acoustics of any hall in the North West. Saturday night celebrity concerts included top-class entertainment for a penny. The idea was that, having been introduced to the hall on Saturday, people would find it easier to come to services on Sunday, and the idea worked. Thousands attended the entertainments and so many became involved

Victoria Hall.

that a similar hall was built on Bradshawgate: the King's Hall, which opened in 1907. An extension to Victoria Hall was completed in 1934.

Behind the four theatre-style mahogany doors on Knowsley Street is a huge complex of offices, rehearsal spaces, classrooms, kitchens and storerooms as well as the magnificent concert space, which can host up to 3,000 people. Since the beginning the mission offered much besides entertainment and worship: choirs, an orchestra, Boys' Brigade units, women's groups, a shelter for homeless girls, schooling for half timers, a brotherhood for men, drama groups, a loan store for poor families, a Goose Club helping poor people save for Christmas and Sunday schools, which by the 1930s catered for 1,200 pupils with 124 teachers. The success of Victoria Hall saw grumbling from other Methodists and a complaint from licensed cinema owners miffed at how cheap it was to watch a film there. They pointed out that the hall was only licensed for worship, not showing films.

Temperance was a priority too. In the early years the Aggressive League of around fifty men would scour pubs on Saturdays, encouraging men to attend. Often those persuaded to come along had no idea they should remove their hats in a church. The mission's evangelistic offer included open-air meetings, street concerts and services on the Town Hall steps that attracted hundreds. This theme carried on to the 1970s, when scores of crusaders ventured out each Saturday to pubs and theatre queues seeking converts. Each Monday involved door knocking, canvassing for souls. In 1988, still pursuing the theme of getting people into the hall, a café was opened for the public.

The mission has a smaller footprint these days, but the vibrancy of the community survives and many of the activities. The building itself, despite real questions about its financial viability, remains a remarkable feature of the Bolton landscape. Take the tour.

Victoria Square (BL1 1RU)

When Christmas was over all eyes turned to Victoria Square. Gaudy tents, garlands and pie stalls appeared. Bearded ladies, challenge boxers and showmen of every stripe touted for custom and great steam engines powered wurlitzers and rides. Bolton's New Year Fair was a noisy treat for all, save those who worried that such tawdry fun threatened working people's moral welfare. The fair moved to Ashburner Street in 1929, restoring a bit of gravitas to the square, though today's August Food and Drink Festival offers something of that old excitement.

Victoria Square was named in 1897, during Victoria's Diamond Jubilee. It is here that monarchs are ceremonially welcomed, Christmas lights turned on and Remembrance Day commemorated in front of the imposing war memorial. Traditionally also those with views to expound did so in the square. Until the 1970s speakers willing to risk rain and ridicule would stand on the Town Hall steps and make their pitch: theological themes on the left of the steps and political persuasion to the right. The rule was that to hold the ground you had to be speaking; stop and someone else could take over.

Above: Victoria Square and the war memorial.

Right: Phil Harker, a regular on the steps in 1934. (Courtesy of David Neville)

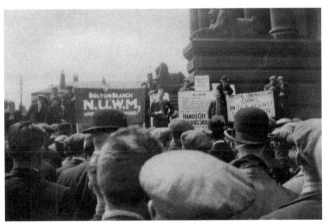

The square is also where suffragettes poured thick ink into all three postboxes in March 1913, where Bertie Lewis patrolled each Saturday until recently, protesting the madness of nuclear weapons and Bernard Mills, teetering backwards in his wheelchair, sold his lighters and tissues.

The square's central importance was demonstrated on the first and second days of December 1988. On the Thursday the queen came to Bolton to open the new swimming baths, the Water Place and the refurbished Market Hall. 'A very nice shopping mall' was all she could think to say about it. That day, despite children not being given the day off school, 6,000 people filled the square to welcome her. The following day several hundred members of the Muslim community gathered in the square to demonstrate against Salman Rushdie's book *The Satanic Verses*. This peaceful gathering, unlike what followed, was the first street demonstration against the book anywhere on earth.

Walker Fold (BL1 7NP)

Walk up the sixty-three steps from Barrow Bridge and follow the path towards Winter Hill. A kilometre along the path a small settlement clusters against a tight bend in Walker Fold Road. Here sits the house owned until 1963 by John Ormrod, a former architect. He had worked for a while with James Wallace, an architectural draftsman with Bradshaw, Gass and Hope. Born in 1850, Wallace was fascinated by literature and established a group, including Ormrod, which met weekly in his home on Eagle Street. Jokingly called the Eagle Street College, the group soon developed a passion for Walt Whitman's free verse, which extolled the joys of the natural world and male comradeship. Wallace and his friend Dr Johnston went so far as to visit Whitman in Philadelphia in 1889 – a visit that led to a burgeoning correspondence between Wallace, his friends in Bolton and Whitman and his American followers. This continued after the poet died in 1892. Wallace, a charismatic man, was a friend to many – ordinary people as well as the great and the good – such as Keir Hardie and Edward Carpenter. He attracted a following of the like-minded from across the country.

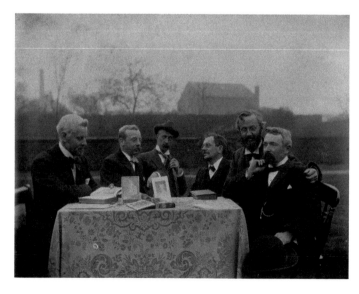

Whitmanites – a garden gathering. (© Bolton Council. From the Collection of Bolton Library and Museum Services)

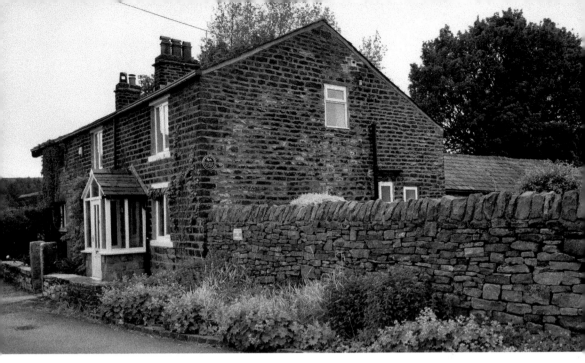

Walker Fold today.

The Bolton group called Whitmanites carried on through the First World War, never more than a few dozen, and continued after Wallace died in January 1926. He had accumulated a vast collection of Whitman-related books, papers and letters and gained an international reputation as an expert on Whitman's work. On his death libraries from across the world expressed an interest in buying it. But his amanuensis (and adopted daughter) Minnie Whiteside, stubbornly kept the collection together. Over the next thirty years the original Whitmanites died off, having no new blood attracted to the group, its yearning romanticism anathema to literary sensibilities after the shock of the First World War. Meanwhile Whitman had become a towering figure in American letters, but Minnie hung on to what she had. Eventually, old and defeated, she passed on this unique collection to Bolton Library.

A hundred years ago John Ormrod's house at Walker Fold was often the site of a stop for tea on the annual walk the Whitmanites took on their hero's birthday, 31 May. This died out in the 1940s, but was revived thirty years ago by a new breed of Whitmanites. Watch out for them each spring: a diverse band, old and young, raggedy and sleek, each wearing a sprig of lilac. They wend their way uphill, carrying a three-handled loving cup to be passed around when they stop here and there to read from Whitman's work. A little romance returned to a workaday world.

Wanderers (Bl3 2QS)

Bolton Wanderers was one of the teams born with temperance aspirations. They were so named as at first they had no permanent ground. Eventually in 1895 the Wanderers

settled at Burnden Park, a mile out of town on Manchester Road. The team secured and maintained, even in the worst of times, considerable local devotion, and along the way four FA cup victories have cheered fans as did victory in the 1945 Northern League Cup over Manchester United. Players like David Jack, Nat Lofthouse and John McGinlay have warmed fans' hearts and years spent in the upper tier of English football confirmed the importance of the club and the town. But football has troughs as well as peaks, and as I write the Wanderers, occupants since 1997 of a sensational stadium at Middlebrook, are struggling back from a deep trough. But life goes on. The real low for the team was what has been described as the forgotten tragedy.

On the afternoon of 9 March 1946 thousands went to Burnden. It was the second leg of a cup tie against Stoke, whose star player was that wizard Stanley Matthews. This was the biggest Wanderer's match since before the war and some say 80,000 tried to get in. Thousands watched the match aware of pushing and shoving in the huge crowd, alarmed by the crush possibly, but no more. There was no evacuation plan, no communication between the police and the crowd, and no tannoy, and because of the huge crowd the authorities closed the turnstiles long before kick-off. Thousands still outside headed for the railway embankment, where many managed to get in. The press of people caused rotting barriers to collapse below them and led to thirty-three deaths. But as the game was allowed to continue, astonishingly, thousands went home ignorant of the horror. If they called in for a pint on the way they were likely to have got an earful once home as everyone else in town knew of the tragedy from the wireless.

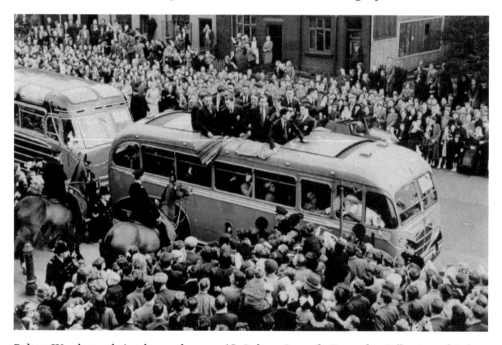

Bolton Wanderers bring home the cup. (© Bolton Council. From the Collection of Bolton Library and Museum Services)

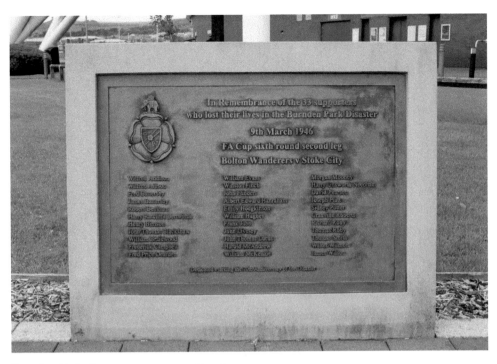

Burnden Park disaster commemorative plaque.

Watermillock (BL1 8TJ)

Today Watermillock is a restaurant, sitting sedately back from traffic scurrying along Crompton Way. Built in 1880, for thirty years it was the home of the Thwaites, whose bleachworks, Eden and Thwaites, was just down Blackburn Road. Barely 2 miles from Bolton, Watermillock was sheltered from the mirk of industry in a protected sylvan setting. The Thwaites family sold up in 1910 and Watermillock's size and seclusion made it a perfect spot for a military hospital in the First World War. But soon the place was threatened, the 1920s being the decade when big houses, subject to land taxes and inheritance tax for the first time, were demolished in numbers. Service as an Anglican retreat saved it for a while and it was used as a campsite for Scouts. Then the Spanish Civil War came along. Some were appalled by British neutrality between the Soviet-backed Republic and Nazi-backed Nationalists and an entirely independent Children's Committee decided to offer a haven for 4,000 Basque children. In 1937 fifty-six of them came to Watermillock. During the Second World War this rambling building, now easily accessible to town via Crompton Way, hosted the Women's Voluntary Service. A thousand Bolton women volunteered for the WVS and Watermillock was used as the administrative headquarters, meeting place and storehouse for blankets and clothes.

After the war the council earmarked it for further use. On 7 July 1947, as the NHS was created, welfare services for old people were overhauled with the abolition of

Watermillock.

the Poor Law. Most councils struggled on using their old workhouses as homes for old people well into the 1960s. Bolton's approach was both humane and visionary. Several large buildings were turned into residential homes, including Watermillock. It remained a care home for the next thirty-five years. The present use as a restaurant completes a varied career as a public utility. Strangest of all is the look of it inside. Go into the entrance lobby and the grand staircase is no different today from when the Thwaites family lived there in 1900.

Watkins, James (BL1 1RU and BL5 3AZ)

By the time Bolton's Town Hall was opened in 1873, slavery in the United States had been gone for a decade. But the tympanum (the decorated triangle above the columns at the front) includes the carved image of a small black boy carrying a basket. At that time, and for decades to come, cotton was still grown by former slaves and Bolton's cotton manufacturers were aware of that legacy. Long before the American Civil War,

Town Hall tympanum.

US slavery was a matter of public debate in Bolton. There was an active abolitionist society in the 1840s and even an *Ethiopian Entertainment* at the Star Music Hall in Churchgate, a moving tableau of slave life.

Soon after that a real slave arrived. Young Sam Berry was brought up on a plantation in Maryland. He escaped but was recaptured. In the depths of despair, he converted to Methodism, changed his name to James Watkins and escaped again. After a harrowing time he settled in Hartford, Connecticut, and married. But in 1851 he fled again. The 1850 US Fugitive Slave Act extended the powers of those hunting escaped slaves into free states and Watkins's liberty was jeopardised. This time he came across the Atlantic to England where, after a poor welcome in Liverpool, he settled in Bolton. Encouraged by powerful local abolitionist supporters, including Robert Heywood and Henry Ashworth, Watkins took up lecturing on behalf of his enslaved compatriots. Throughout 1851 this uneducated lad from an alien culture and oppressed ethnicity, gave at least thirty lectures to roomfuls of affluent gentlemen, making a considerable success of it. We know this because one of Watkins' sponsors, Mr Abbatt of Market Street, published the young man's autobiography, eloquent testimony of the full horrors of chattel slavery. This initial foray into public speaking led to hundreds more lectures across the whole of the UK, after which Watkins settled with his wife in Birmingham. But she became ill and returned home, followed by Watkins himself after Lincoln abolished US slavery in 1863.

Although Watkins cannot be the black boy on the Town Hall's tympanum, he certainly moved society, fuelling general support for the Union cause in the coming American Civil War. And he is still here. Go to Westhoughton and on the wall of the Provenance Food Hall, No. 46 Market Street, you'll see James Watkins' face surveying the scene.

James Watkins' head, Provenance Food Hall, Westhoughton.

Wood Street (BL1 1DY)

Wood Street is a 100-yard-long cobbled way in the town centre. An air of eighteenth-century calm contrasts with its brazen neighbour, Bradshawgate. Wood Street is famous for two things, both relating to the number 16. It was the birthplace in 1851 of Bolton's most successful businessman, William Hesketh Lever, but has also been the home for well over a century of the oldest surviving Socialist Club in Britain – a noisy, radical presence drowning out any echoes of a noisy capitalist past.

But there were other residents. At the end of the nineteenth century Bolton's premier architect, Richard Knill Freeman, had an office at No. 17. His firm worked on many buildings in town including Heaton Cemetery, the Infirmary, High Street Baths and Chadwick's Museum.

Bolton's brand-new Child Welfare Department was at No. 4 in 1926. Two Children's Visitors shared an office: Ada Wainer, puritanical and exacting, and Annie Higginson, who falsified reports of visits she had not made. Ada complained about

Wood Street –
capitalists, socialists,
mesmerists.

Annie to the Poor Law boss Henry Cooper. Annie responded in spirited defiance. Cooper moved them into different offices, but conflict arose again over access to the single typewriter. In the end Cooper made Higginson an offer she couldn't refuse. Rather than be sacked she resigned in return for a glowing reference – a document still in Bolton's archive.

But the strangest inhabitant was probably Dr Joseph Haddock, who lived at No. 8 between 1846 and 1861. He worshipped at the Swedenborgian Church in Bury Street (where Samuel Crompton had worshipped), practised as a doctor and developed a national reputation as a mesmerist (hypnotist). At that time the use of ether as an anaesthetic was new, electricity was giving up its secrets and mesmerism was all the rage. Haddock investigated all three in his search for the ultimate truth. He gave lectures at the Temperance Hall and by chance discovered that his servant Emma Lowe had clairvoyant powers. She demonstrated this time and again finding lost bank notes, stolen money and sensationally identifying the precise location of the lost Franklin Arctic expedition, although this was conveniently unverifiable at the time. Dr Haddock presented Emma's examinations as a contribution to science, and many came to test her abilities, including cultural luminaries Mrs Gaskell and Harriet Martineau. Emma was never unmasked as a fraud but over time her notoriety subsided. She married Edward Hailwood, a jobbing tailor, and had four children. By 1881 she was living at Bridgeman place working as a washerwoman.

Worktown (BL1 2PP)

Sometimes Bolton is referred to as Worktown, a mundane epithet concealing a unique cultural legacy.

In 1936, an anthropologist came to Bolton, stayed at the Lever Arms pub on Nelson Square and got a job in a mill. Tom Harrisson thought the establishment in Britain had no idea how ordinary people functioned and he aimed to find out. His background in ornithology and in living with traditional villagers in the West Pacific had convinced him you only find out how people tick by being with them, watching and listening. With Charles Madge, a poet, Harrisson started the Mass Observation Bolton Study, supported by rich and influential local people whom Harrisson with his charisma, determination and Oxbridge background, had charmed. This extraordinary effort lasted between February 1937 and September 1940 and involved well over a hundred volunteers, who were sent out to watch, listen and take notes on every conceivable aspect of local life: rounders matches, pancake recipes, graffiti, voting behaviour, street betting and lots more. All the reports survive – some nicely typed, others mere scribbles. All are available in Bolton Central Library, thousands of documents, millions of words, 800 photographs. Reports of Fascist and Communist Party meetings jostle with accounts of sports

Sweet Green Worktown mural.

days, church services, prostitutes in Bradshawgate, Remembrance Day behaviour, children's games, swearing, what fat was used in cooking and people's favourite films – tiny slivers of insight and stark reminders of how hard, communal and colourful life was back then. This kaleidoscopic view of Bolton as the Second World War approached is well maintained by the library, but few in Worktown honour or use this fabulous, unique, legacy. Go and have a look.

X

X-records (BL1 2EG)

The first gig Steven Meekings went to was when he sneaked off to see his punk heroes, the Ramones, at the Manchester Apollo in 1977. Later in the 1980s he travelled the North West as part of his training to be a surveyor, always on the lookout for the perfect record shop. He never found it, and when he was made redundant he had a go at creating his own 'perfect' record shop. This was in the late 1980s when big chains were knocking out independents. Nothing intimidated Steve. He took the plunge, always going the extra mile, seeking out what customers wanted no matter how obscure. The current X-records on Bridge Street is bucking the streaming trend. Steve sells CDs, 78s, DVDs and heaps of vinyl, along with all the paraphernalia that goes with bands and fandom. People come from all parts of the UK as well as Bolton, where customers who started visiting thirty years ago come in today with their grandchildren. Steve's passion now includes charting the history of shops that sold 78 rpm records and the chronicling of gigs in Bolton: Freddy Mercury's stage debut on the bandstand in Queen's Park, Jimi Hendrix disconsolate in Bradshawgate after a bad gig at the Odeon and Van Morrisson having a pint in the Man and Scythe.

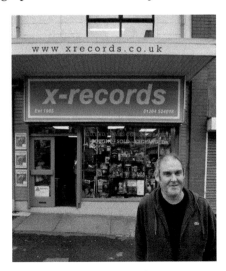

Steve at X-records.

Ye Olde Pastie Shoppe (BL1 1HU)

Bolton has a reputation for food that can be eaten on the go, a legacy of snatched lunch breaks from work in the mill. A hundred years ago the town boasted over 200 fish fryers. Warburton's (from 1876), Carrs Pasties (from 1938) and Greenhalgh's (from 1957) have kept up the tradition.

But the true heart of food on the go in town is Ye Olde Pastie Shoppe on Churchgate. The bakehouse is at the back, behind the bite-sized servery where pasties produced to a secret recipe sell out every day. The Walsh family have run this Bolton institution since 1898. Chris Walsh, the great-, great-nephew of the founders presides, but his mother, Marie, at eighty-two, still serves. Comments here show the affection felt towards the place:

> I have lived in Bolton ... all my life and I'm not exaggerating when I say that Ye Olde Pastie Shoppe is part of the fabric of Bolton life.

> If ever visiting Bolton this pasty shop is a must – very old school no card machine, no deliveries, no Saturday opening.

> Now they are serving with gravy and mushy peas. It's a new level of comfort eating ... it just does the trick.

Marie and Ye Olde Pastie Shoppe.

Z

Zakariyya Jaame Masjid (BL3 5LJ)

All groups of immigrants have to 'make do and mend' with their religious needs at first. Jewish settlers fleeing Eastern Europe around 1900 used an upstairs room in Central Street and a house in Davenport Street in place of a synagogue. Hindus gathered in a range of houses before temples were established in the 1970s. Muslim settlers met for prayer at first in the Empress Ballroom, then from 1964 used No. 43 Walter Street, Daubhill, and bought Peace Street Methodist Chapel in 1967. Finally, money was raised, all of it locally, to build the Zakariyya Mosque in 2004.

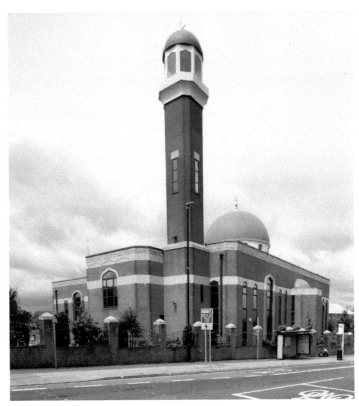

Zakariyya Jaame Masjid.

Zakariyya, the central mosque for Bolton, which can hold up to 3,000 people, is part of the Islamic Cultural Centre (ICC). The ICC is not just for worship but is the co-ordinating body for a comprehensive pattern of charitable and community activity. Although today there is considerable homogeneity among Bolton Muslims, that was not always the case. Although some immigrant pathways are well trod, people arrive from different places with different religious affiliations. The South Asian settlers in Bolton are from diverse backgrounds, though many came from the textile areas of Surat and Bharuch, both in Gujarat. The majority of Muslims in Bolton today are Sunni, committed to the Hanafi school and while there is some diversity in practice and belief between followers of different imams, these are subtle enough for Muslims often to operate as a single community. The range of activities centred on the mosque, the commitment to support people and get into the community is remarkably reminiscent of the activities and ambition of the Methodist Mission at Victoria Hall in its heyday.

Zeppelin Attack (BL3 5AH)

Bolton was not a deliberate target for bombs in either world war, Trafford Park's close packed factories being more attractive for bombers than spinning mills. But bombed it was, by pilots who were lost or in a panic. Even the most tragic bombing,

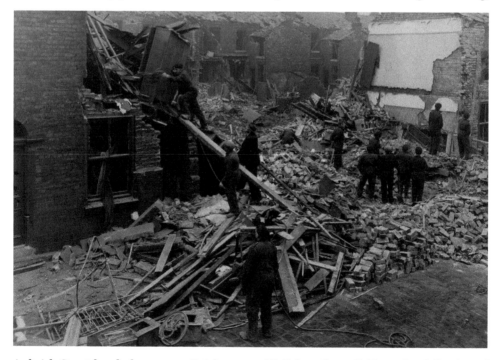

Ardwick Street bomb damage, 12 October 1941. (© Bolton Council. From the Collection of Bolton Library and Museum Services)

on 26 September 1916, was a mistake. Kurt Frankenburger, captain of Zeppelin L21 was floating over northern England looking for targets, but, when he dropped the five bombs on Kirk Street and John Street, thought that he was over Derby. Six homes were destroyed, many others damaged and thirteen people died.

In the Second World War thirteen bombs fell on Edgworth and Affetside on 1 September 1940. No damage was done and Affetside people can feel proud that Hitler targeted them a full week before he took on London. Incendiaries and high-explosive bombs fell regularly thereafter to no pattern – Luftwaffe pilots possibly overshooting Manchester or, like Frankenburger, mistaking what was beneath. The worst toll, when eleven died, occurred when Punch Street and Ardwick Street were hit on 12 October 1941. There is a tale that a brick from that bombing crashed through the roof of Peace Street Methodist Church 400 yards away.

Last Word & Acknowledgements

That's it then. Lots to think about, people to look up, places to investigate. Have fun! Over the years I have learned a great deal from and need to thank Halliwell History Society members, Bolton Family History Society, Bolton U3A history group, the Men's group, Live from Worktown members and every audience to whom I have given lectures. Bolton Library and Museum Service staff have, as ever, been painstaking and enthusiastic in the help given for this project. I also have to thank many people for their time and the material used here: Dave Bagley, Janice Drake, Debbie Booth, David Neville, Layla Hu, John Fox, Richard Horrocks, Baljinder Kandola and Ibrahim Kala. Margaret Koppens, Tony and Jean Booth, Colin Liptrot, Stewart Ball, Bernard Wrigley, John Phillp, George Denton, Barry Massey and Steve Meekings have also helped immensely. Brad Wood took the pictures at great personal cost – thanks, Brad. Finally, thanks to Linda, Liz and Alice, always interested in interesting things.

Every attempt has been made to seek permission for copyright material used in this book. However, if we have inadvertently used copyright material without permission or acknowledgement, we apologise and will make the necessary correction at the first opportunity.

Bibliography

Atkinson, Jeremy, *Clogs and Clogmaking*, No. 113 (Shire Publications)

Bagley, Dave, comments about Urban Outreach

Banglapedia, Serampore Mission (en.banglapedia.org)

Bolton Little Theatre, *75 Years of Drama* (2007)

Bolton Library and Museum Service (boltonlams.co.uk)

 Mass Observation Worktown Study Archive

 Bill Naughton Collection

 James Wallace and Whitmanite Collection

 Bolton Evening News Archive

 Watch Committee Records

Bolton Steam Museum (www.nmes.org)

Booth, Debbie, comments about Rounders

BBC News, 'The Rise and Fall of a Thousand Years of Hultons' (11 May 2010)

Bradshaw, Brian, *Bolton Bred* (Neil Richardson: 1984)

Brown, Isabella (www.basquechildren.org/-/docs/articles/isabellabrown)

Davies, Alan, *Pretoria Pit Disaster: A Centenary Account* (Amberley Publishing: 2010)

Dibnah, Fred, *Steeplejack, Line One* (1983)

Drake, J. D., *Seiges and Battles in the North of England During the Civil War, Chiefly Contained in the Memoirs of General Fairfax and James Earl of Derby, 1785* (Bolton History Centre, Mass Observation Archive, Reel 34, Box 44a)

Drake, Janice, comments about Bolton Little Theatre

Egyptian Exploration Fund Catalogue 1883–99 (egyptartefacts.griffith.ox.ac.uk)

Foxy's Clogs (www.foxysclogs.co.uk)

French, Gilbert J., *The Life and Times of Samuel Crompton* (1861)

Greenhalgh, Shaun, *A Forger's Tale* (Allen and Unwin: 2017)

Hogenns, Peter, Bolton Genealogica (boltongenealogica.blogspot.com/2017/04/the-deathly-hallows-of-bolton-part-i.html)

Horrocks, Richard and Kandola, Baljinder comments about IMRI

Lever, William, *2nd Viscount Leverhulme, Lord Leverhulme, by his son, George Allen and Unwin* (1927)

Kala, Ibrahim, comments about Zakariyya Mosque

McCorristine, Shane, *The Spectral Arctic* (University College Press: London, 2018)

Marsland, Simon, *Bolton Wanderers FC: The Official History 1877–2002* (Yore Publications: 2002)

Massey, Barry, comments about Victoria Hall

Meekings, Steve, comments on X-records

Morrin, Steve, *The Devil Casts his Net* (2005)

Pemberton-Billing, Robin, *The Octagon Theatre, Bolton: from Concept to Reality* (Self-published: 2011)

Rostron, Arthur, *Titanic Hero: Autobiography of Captain Rostron of the Carpathia* (Amberley Publishing: 2011)

Tonge, S. J., *Egerton, Turton Historical Society*, Publication 38 (2019)

Turton Tigers (www.turtonfc.co.uk)

Daniel Tomkins, *Mission Accomplished* (Methodist Publishing House: 1997)

Watkins, James, *Narrative of the Life of James Watkins, formerly a 'Chattel' in Maryland US* (Kenyon and Abbatt: Bolton, 1852)

Wrigley, Bernard, comments about the Octagon Theatre